FILTON AIRFIELD
THROUGH TIME
Andrew Appleton

AMBERLEY

First published 2012

Amberley Publishing
The Hill, Stroud
Gloucestershire, GL5 4EP

www.amberley-books.com

Copyright © Andrew Appleton, 2012

The right of Andrew Appleton to be identified
as the Author of this work has been asserted in
accordance with the Copyrights, Designs and
Patents Act 1988.

ISBN 978 1 4456 1011 5

British Library Cataloguing in Publication Data.
A catalogue record for this book is available from
the British Library.

Typeset in 9.5pt on 12pt Celeste.
Typesetting by Amberley Publishing.
Printed in the UK.

Introduction

The cessation of flying at Filton Airfield in December 2012 marks the end of an exceptional period in history. The history of Filton Airfield *is* the history of aviation in Britain. Many aviation firsts have been achieved and several world records have been broken by products designed and built in the surrounding factories to which the airfield is inextricably linked. Filton Airfield, on its current site, dates back to the First World War, making it one of the oldest airfields in the UK. However, Filton's aviation history goes back even further, to 1910, when the British & Colonial Aeroplane Company started building aircraft in tram sheds at the top of Filton Hill. By the start of the Second World War, the combined factory site at Filton and Patchway was the biggest aircraft manufacturing plant in the world, and it continues to be a centre of excellence today.

Throughout the twentieth century the local aviation industry has been at the forefront of technology. The airfield has been the springboard for many groundbreaking aircraft designs, and it has also been the base for a fleet of airborne engine test beds. There have been some of the fastest aircraft: the racers of the early 1920s, the Type 142 *Britain First* in 1935, and of course Concorde; the biggest aircraft: the Pullman in 1920, the Brabazon in 1949, and the present-day Airbus A380; and the highest-flying aircraft: the record-breaking Bristol-powered aircraft of the 1930s and 1950s.

Filton Airfield has had an important role to play in Britain's military endeavours in the twentieth century, including the design and development of three iconic fighter aircraft: the Bristol Fighter in the First World War, and the Bristol Blenheim and Beaufighter in the Second World War. In addition, the airfield has served as home to training and reserve units from the RFC and RAF. The relationship with the Services was complemented by flying schools run by the factory on behalf of the military. It was also home to a number of defensive detachments during the Second World War and at the height of the Cold War.

This book records the history and many achievements of the airfield, which has played a crucial role in the success of the aircraft industry in the South West of England.

Acknowledgements

I would like to thank the following people for their help in supplying photographs and providing information and support:
Bob Hercock of the Rolls-Royce Heritage Trust, John Battersby and Bill Morgan of the Bristol Aero Collection, Bob Holder, Adrian Cooper of No. 501 Squadron Association, Duncan Greenman of Bristol AiRchive, Geoff Church, Shaun Connor, George Rollo, Adrian Falconer, Sir George White and the team at the Great Western Air Ambulance Charity.
I would also like to give special thanks to Kim Edgar for proof reading and editing the text.

Sources of Reference

The following books and websites have proved invaluable in establishing and confirming some details about Filton Airfield. They are also recommended for further reading:

Barnes, C. H. *Bristol Aircraft Since 1910* (Putnam Aeronautical Books, 1995)

Gillett, Steph, *The Aircraft Industry in Avon and Gloucestershire* (Ironbridge Institute, 1999)

Pudney, John, *Bristol Fashion* (Putnam, 1960)

Wakefield, Ken, *Target Filton* (Redcliff Press Ltd, 1990)

Wakefield, Ken, *Operation Bolero* (Crecy Books, 1994)

Watkins, David, *Fear Nothing* (Newton Publishers, 1990)

White, George, *Tramlines to the Stars,* (Redcliff Press Ltd, 1995)

http://www.flightglobal.com – archive copies of Flight going back to 1909

http://www.aviationarchive.org.uk – charts aviation development at Filton and Patchway

http://www.bristolaero.com – The Bristol Aero Collection

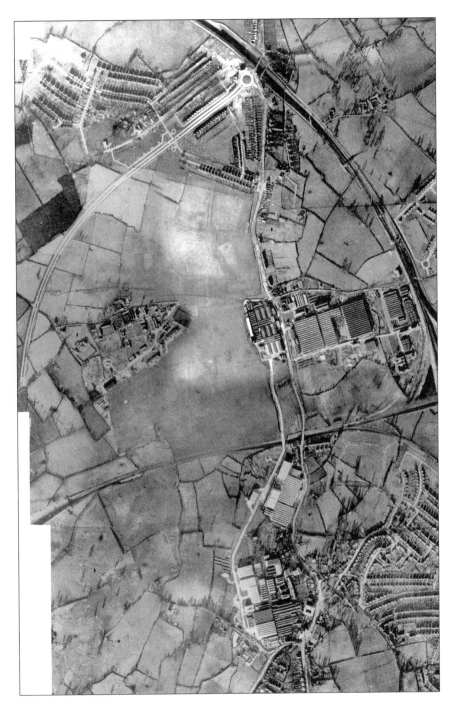

Composite image of the airfield and factories in 1938. The aircraft factories, Filton Works and Rodney Works, are at the bottom, and the aero-engine factories, East Works and West Works, are right of centre. The RAF base is left of centre. The airfield had just doubled in size with the closure of Hayes Lane, which ran just north of the RAF base to Gloucester Road, which runs north to south. The Filton bypass, which runs south west from the roundabout at the top, was still under construction. (RRHT)

CHAPTER 1

The Early Years

Bristol entrepreneur Sir George White was a pioneer in trams, trains and buses, and as managing director of the Bristol Tramways Company, he introduced the electric tram to Bristol and many other cities in the UK. He was fascinated by new technology, particularly transportation that could be developed in a commercial manner. In 1909, he visited an air meet at Pau in France, which was at the vanguard of aviation, where he met the pioneering aviators of the day, including Wilbur Wright. Not long after, he and his brother went to Paris to meet several aeroplane designers, and returned to Bristol with a licence from Société Zodiac to build a biplane of their design that was 'guaranteed to fly'. The British & Colonial Aeroplane Company was formed on 19 February 1910, and two tram sheds at the tram terminus in Filton were acquired from the Bristol Tramway Company. The company had an initial investment of £25,000, substantially larger than any British aeroplane manufacturer of the time, making it the first British aircraft factory established on a commercial footing. The only two significant earlier factories, Handley Page and Short Brothers, were established by the pilots themselves, and had initial investments of £500 and £600 respectively. Brooklands in Surrey, with its 'Aviation Village', was the place where likeminded aviators flew their contraptions. The first Zodiac was taken there for its maiden flight in May 1910. The guarantee to fly came in useful, as it barely managed a brief hop. The aeroplane and several others under construction were subsequently scrapped.

The next aeroplane from the factory was much more successful. The Bristol Biplane, affectionately known as the Boxkite, was a flagrant copy of an aeroplane designed by Henry Farman in France. He complained, but there were no legal proceedings, as the Bristol aircraft was of much better quality – a product of years of experience in coach building. British & Colonial leased a shed at the new flying ground at Larkhill near Stonehenge, and it was from here that the Boxkite made its first flight on 29 July 1910, reaching an impressive height of 150 feet. A production line at Filton was set in motion, and Boxkites were allocated to 'Bristol' flying schools run by British & Colonial at Larkhill and Brooklands, and dispatched on sales tours to Australia and India. To generate interest, Sir George arranged an aerial demonstration from Durdham Downs in Bristol on 14 November 1910, which included flights over the Clifton Suspension Bridge for a few lucky passengers.

Although the factory at Filton was well established in the manufacture of Boxkites by the end of 1910, aeroplanes were still taken to Larkhill for flight testing. In 1911 Sir George White revealed his vision for a chain of 'Air Stations' – company-run flying grounds from Filton, to Larkhill, Brooklands, and the latest 'Bristol' school at Eastchurch in Kent. An area of grass next to the factory came into use as a flying ground in 1911. It is almost certain that the first flight to Filton took place on Saturday 1 April 1911. Maurice Tabuteau was one of several experienced

French pilots taken on by British & Colonial as test pilots and instructors at Larkhill. His memoirs record that he was curious to see what was happening at Filton, and decided to fly to Filton unannounced. He set off from Larkhill around 4.30 p.m. on Friday 31 March 1911 in a Military Boxkite, which had extended upper wings and a 70 hp Gnome rotary engine. The engine developed a valve problem four miles from Filton, and he was forced to make a *vol plané* (gliding descent) at Mangotsfield. Engineers were dispatched to make repairs, and the following day he continued on his journey to Filton, arriving twenty minutes later. He was chastised on arrival for undertaking such a dangerous cross country flight; however, the episode, along with two other long distance flights in Military Boxkites the same weekend, highlighted the ease with which the aeroplane could be flown cross country. Shortly after this Tabuteau was re-allocated to the Filton Works, and set up the flying ground along with Herbert Thomas, nephew of Sir George White, and at 18 Britain's youngest certified pilot.

A few weeks later, on Easter Monday, 17 April 1911, at the invitation of the Duke of Beaufort, Tabuteau and Thomas flew from Filton to Badminton Park where a house party was taking place. After demonstrating the versatility of the Boxkite, several distinguished guests got the chance to fly as a passenger on a series of flights from the lawn in front of Badminton House.

In March 1911 Stanley White, son of Sir George, published the world's first pilot's log book, which was printed on 'paper unaffected by damp' and priced at 7s 6d. The first use of this book was by Henri Jullerot, one of Bristol's test pilots, when he flew from Filton Works to 'Amesbury Grounds', another name for Larkhill, on 6 June 1911. He set off at 6.05 p.m. and arrived at 7:28 p.m., covering 50 miles, using 4 gallons of petrol and 2 gallons of castor oil. He records that he followed the railway line to Badminton, and then flew south-east across the fields. What it doesn't record is that he flew the route by compass and memory, as he realised once airborne that he was sitting on his map.

Throughout 1911 and 1912 the Filton Works continued to build increasingly more sophisticated aeroplanes. Filton House, an eighteenth-century mansion, was leased for office use, and then purchased in April 1912. The company employed several keen enthusiasts to design new aircraft, including Pierre Prier, Gordon England, and Henri Coandă, a Romanian engineer, who designed a series of monoplanes at Filton. The War Office was sceptical of the safety of monoplanes over biplanes, and this was highlighted when a Bristol-Coanda monoplane crashed at Wolvercote, Oxfordshire, in September 1912, killing the experienced instructor Edward Hotchkiss and his pupil. This led to a ban on monoplanes by the War Office. With the production lines committed to monoplanes, the Filton Works were obliged to accept a contract to build the B.E.2, a biplane designed by the Royal Aircraft Factory at Farnborough.

In early February 1914, a new Bristol aeroplane took to the skies; it was to establish British & Colonial as one of the leading aircraft manufacturers in the world. Named the Baby Biplane, it was designed by Scotsman Frank Barnwell, who later became chief designer and was responsible for almost all Bristol aircraft up to the start of the Second World War. The biplane, later named the Bristol Scout, achieved large orders from both the Royal Flying Corps and the Royal Naval Air Service.

The Bristol Schools at Larkhill and Brooklands were requisitioned by the military in June and September 1914 respectively, and test flying moved elsewhere, ultimately to Filton. In 1916

several new buildings were constructed around the former tram sheds, including an erecting hall, fabric and dope shops and a fitting shop, and a canteen was built on the site of the flying ground. In late 1915 a new flying ground was set up to the north of the site, on flat land at the bottom of the hill. Aeroplanes were towed down Gloucester Road to reach the airfield.

By 1915 the usefulness of aircraft in the war in France had been realised, and demand had risen such that more aircraft and airmen were required. The Royal Flying Corps (RFC) began using Filton to train pilots and build up squadron strength, before relocating to defensive airfields on the eastern coast of Britain and to the front line in France. A number of buildings were erected beside Hayes Lane in the north-western corner of the airfield, including a row of five 1915 pattern flight sheds. These were timber frame structures with corrugated iron cladding, two of which survive today. The first squadron at Filton was 20 Squadron, which had formed at Netheravon in September 1915 and moved to Filton on 15 December. One month later the squadron was ready for action and relocated to St Omer in France. Next was 33 Squadron, which formed at Filton on 12 January 1916 and comprised B.E.2s and crew from 12 Squadron, and was soon sent to Lincolnshire in the defence of British shores. Throughout 1916, several more RFC Squadrons established themselves at Filton including 42 Squadron (April to August 1916), 19 Squadron (March to July 1916), 66 Squadron (June 1916 to March 1917) and 62 Squadron (August to July 1917).

In early 1917, the role of receiving aircraft from factories was organised into Aircraft Acceptance Parks, and No. 5 AAP was established at Filton. Three triple-span Belfast truss general service sheds were built in the north-east corner of the airfield for the AAP, and two more Belfast sheds were built on the Hayes Lane site – one single and one triple. These two still exist, although the single is due to be demolished. It is possible that the sheds were built by prisoners of war, as POWs were used as unskilled labour on several other airfields in the UK in 1917. No. 5 AAP accepted aircraft built by British & Colonial at Filton, Bristol Tramways at Brislington, Parnall's in Yate, and Westland in Yeovil.

In 1910, the British & Colonial Aeroplane Company leased these former tram sheds on Homestead Road, and set up Britain's first commercially-run aircraft factory. Sadly, the buildings were demolished in 2005. (Bristol Aero Collection)

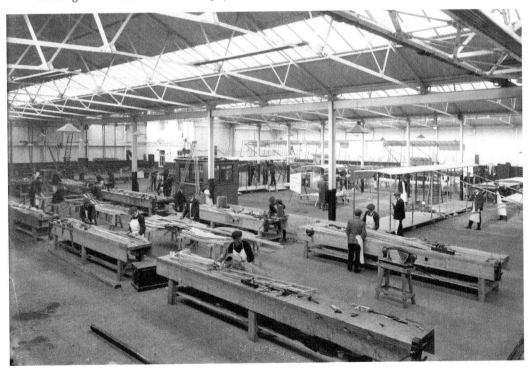

Boxkites under construction in the Filton Works in about 1910. (Duncan Greenman via RRHT).

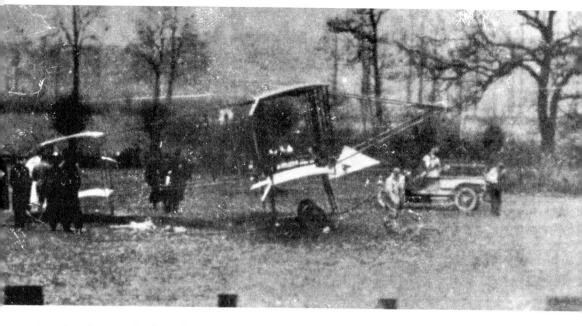

A grainy photograph of a Boxkite at Mangotsfield on 1 April 1911, on the occasion where Maurice Tabuteau flew from Larkhill to Filton. He was forced to land at Mangotsfield with a faulty engine. This is the first recorded flight to Filton. (Bristol Aero Collection)

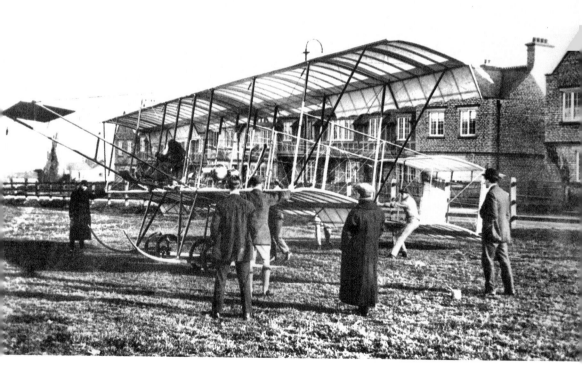

A Boxkite with wing extensions on the flying ground on Fairlawn Avenue, next to Filton Works, in about 1911. The gentleman with the long coat and cap is thought to be Sir George White, founder of the British & Colonial Aeroplane Company. (Duncan Greenman)

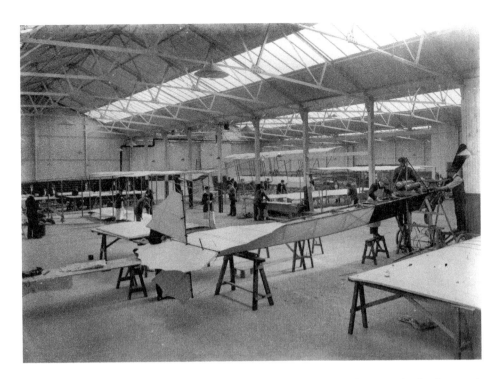

Bristol Tractor Monoplane No. 35 under construction, with Boxkites in the background, around February 1911. Like the Boxkite, it was heavily influenced by a French aeroplane design, the Antoinette. It was damaged on its first take-off, and it was decided not repair it. (Duncan Greenman via RRHT)

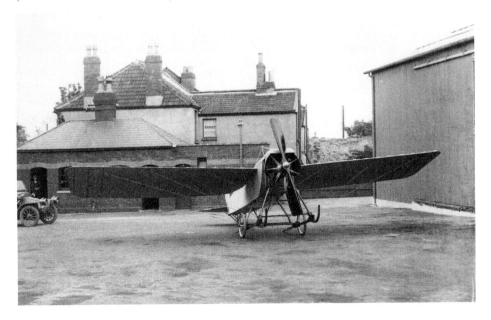

Pierre Prier was employed by British & Colonial in June 1911 to design a monoplane for racing. A Bristol-Prier Monoplane is shown here outside the Filton Works. (Duncan Greenman via RRHT)

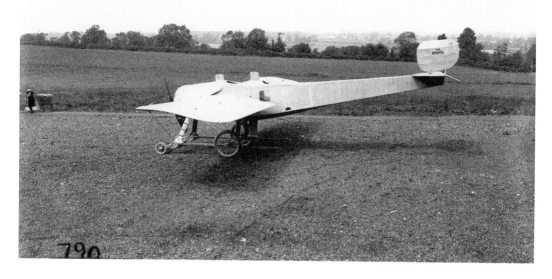

Henri Coandă joined the company in January 1912, and designed a series of monoplanes. No. 153, shown here at Filton, was exhibited at the Olympia Show in February 1913. (Duncan Greenman via RRHT)

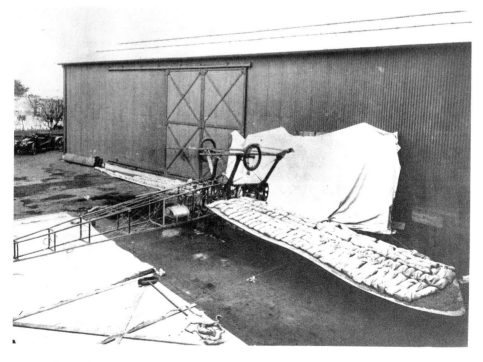

A Bristol-Coanda monoplane undergoing wing stress testing. (Bristol Aero Collection)

This drawing was part of a full page advertisement that appeared in *The Times* in 1913. It depicts a very active flying ground to the rear of the factory. Flying at Filton actually took place on a patch of ground next to Fairlawn Avenue, just to the right of this view. (RRHT)

A War Office ban on monoplanes and an insistence on government designed aircraft forced the company to accept a contract to build the B.E.2. The factory eventually built over a thousand B.E.2s. This example is a B.E.2e, under construction in 1916 or 1917, after the type was virtually obsolete. (Duncan Greenman via RRHT)

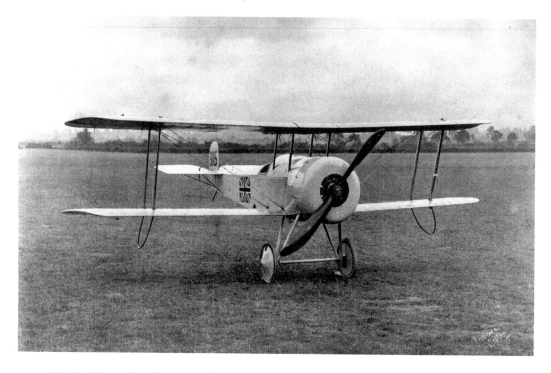

A Bristol Scout C on the new airfield in late 1915. This example, 3015, was destined for the Admiralty. All Scout Cs were built by the Bristol Tramway Company at Brislington, as the Filton factory was fully resourced to building the B.E.2. (Duncan Greenman via RRHT)

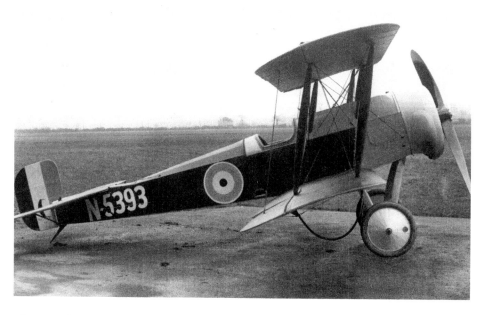

This Bristol Scout D, N5393, was delivered to the Admiralty in late 1916. (Duncan Greenman via RRHT)

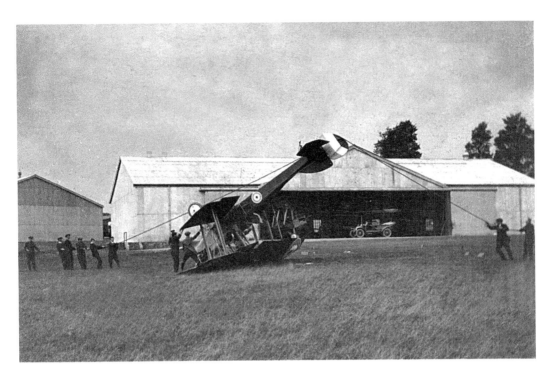

A B.E.2e is righted after a nose-over on the airfield. The flight shed behind still survives, and is Grade II listed because of its rarity. (Duncan Greenman)

Two Bristol M.1 Monoplanes under construction at Filton in autumn 1916. Note the rotary engine ready for mounting. The Monoplane was a private venture by the company, as a fast single-seater scout. (DG)

Bristol M.1B monoplane A5140 at Filton in December 1916, with a B.E.2 behind. The M.1B was rejected by the War Office as its landing speed of 49 mph was supposedly too high; however, the real reason may have been the resistance to monoplanes. (Duncan Greenman via RRHT)

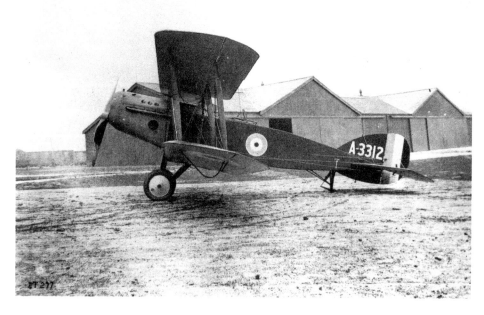

Bristol F.1A Fighter A3312 at Filton in early 1917. (Duncan Greenman via RRHT)

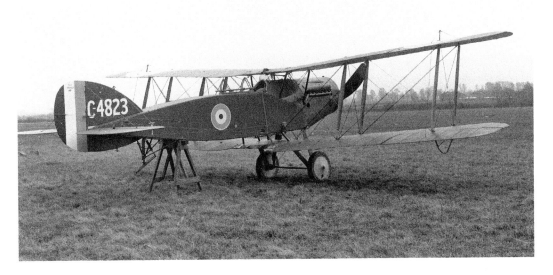

This Bristol F.2B Fighter, C4823, was built at the Brislington Works around December 1917, and test flown at Filton. (Duncan Greenman via RRHT)

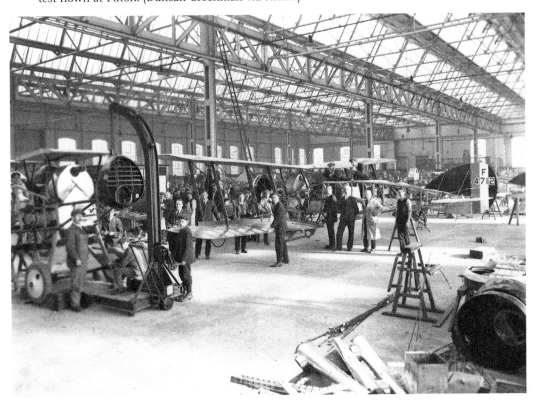

Bristol Fighters under construction at Filton in 1918. (Duncan Greenman via RRHT)

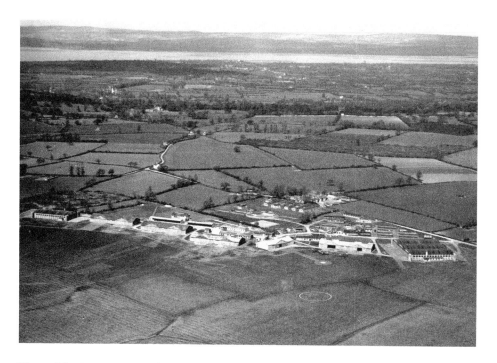

View of the RAF camp at Filton around 1920, looking north-west. Of the seven flight sheds visible here, four survive today, although the leftmost shed is due for demolition, leaving the three on the right. (Bristol Aero Collection)

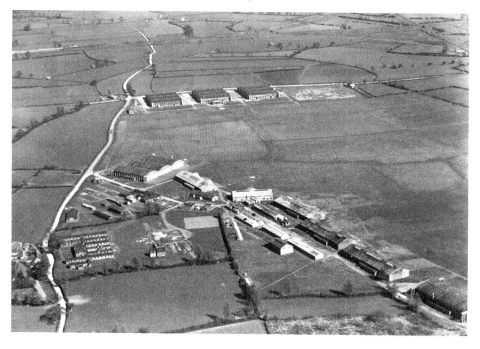

The airfield at around the same time as the previous photograph. Hayes Lane is on the left, and Gloucester Road is behind the three Belfast sheds in the distance, which were home to No. 5 Aircraft Acceptance Park (AAP). (RRHT)

CHAPTER 2

Between The Wars

Filton Works built 2,000 aircraft in 1918, but the end of the First World War brought a sudden halt to the expansion in the aviation industry that had taken place during the war. Orders for military aircraft were cancelled, the AAP closed, and the factory had to find alternative work for its employees. In March 1920 the company assets were transferred to the Bristol Aeroplane Company, and British & Colonial was wound up, essentially to avoid a hefty tax payment. A few months later the company took over the aero-engine assets of the bankrupt Cosmos Engineering Company, which specialised in radial piston engines. The design team, led by Roy Fedden, relocated from nearby Fishponds to the northernmost hangar of the former AAP site. Over the next two decades, the engine side of the business effectively kept the company afloat.

The aircraft factory continued to build aircraft through the 1920s, but in smaller numbers. Reconditioned Bristol Fighters were the core business, the last one being delivered in 1927. A number of Bristol Fighters, named the Tourer and the Seely, were modified to carry passengers. Designs for a large commercial transport aircraft in the 1920s were relatively unsuccessful. Several flew in prototype form – the fourteen seat Pullman triplane in 1920, the Ten-Seater in 1921, the Brandon Air Ambulance in 1922 – but only a couple made it into operational service. Several racing aircraft were built: the Bullet, the M.1D, 'Barrel' Racer, and Badminton, each with varying amounts of success. These also acted as promotional tools for the Bristol engines that powered them. New fighter designs also appeared – the Bullfinch, Bloodhound, and Boarhound – but none matched the success of the Bristol Fighter. The Filton Works finally achieved success with the Bristol Bulldog biplane fighter. First flown in 1927, the Bulldog was ordered by the RAF as their front-line fighter, and export orders came from far and wide, including Japan, Latvia, Sweden, Finland, Estonia, Australia, and Denmark.

In 1923 the Bristol Flying School was formed, one of four set up by British aircraft manufacturers on behalf of the Air Ministry to train reserve pilots for the RAF. The chief instructor was Cyril Uwins, Bristol's Chief Test Pilot. Uwins had served in the First World War as a pilot in France, joining the Filton AAP in 1917. He was seconded to the factory as a test pilot in August 1918, and became the Chief Test Pilot in May 1919. He went on to fly the maiden flight of every new Bristol type up to 1947 – fifty-four first flights in all – before becoming a director of the company.

The Bristol school initially used a purpose-built aircraft, the Bristol Lucifer Training Biplane, and for more advanced training, a version of the Bristol Fighter with a more powerful Siddeley Puma called the Puma School. This was replaced in 1924 by a similar biplane with a Bristol Jupiter engine. By 1927 the Lucifer biplanes were known as Lucifer PTMs (for Primary Training Machine), and the Jupiter Schools as Jupiter ATMs (for Advanced Training Machine). The school initially consisted of pilots who had learned to fly during the war and only needed a

refresher course and 12 hours of flying per year, but in 1925 the syllabus was expanded to include new entrants. The de Havilland Tiger Moth became the standard trainer in 1932. A year later the school expanded to include more ground based tutoring, such as air navigation, and a new building containing lecture rooms and a students' mess was built.

Cyril Uwins hit the headlines on 16 September 1932 by setting a new world altitude record in a flight from Filton. This was made possible with the latest version of the Bristol Pegasus piston engine, the S3, which contained a supercharger. A production Pegasus S3 engine was fitted to a Vickers Vespa, a two seat reconnaissance biplane used by the British Army. This combination enabled Uwins to set a new altitude record of 43,976 feet. What is all the more remarkable is that the Vespa had an open cockpit, and all Uwins had was electrically heated clothing, a rudimentary oxygen supply, and just enough space to hunker down out of the blast of freezing rarefied air. This flight led to the Pegasus being chosen for the first flight over Mount Everest the following year.

In the mid-1920s two Auxiliary Air Forces were formed as a backup for the regular RAF. The Special Reserve Air Force consisted of squadrons located near industrial centres, and contained a mix of regular RAF staff, including commanding officers, and locally recruited volunteer pilots and ground crew. The Auxiliary Air Force was similar, but consisted almost entirely of volunteers, and was run in a similar way to the Territorial Army. 501 Squadron was formed at Filton as a Special Reserve Squadron on 14 June 1929. Eleven months later it was given the more formal title of No. 501 (City of Bristol) (Bomber) Squadron. Its first aircraft, an Avro 504N biplane, arrived on 23 August, and the first reservists joined on 14 October. These volunteer reservists had full time jobs in the area, some from the aircraft factories next to the airfield, and were given expenses and an annual bonus if they completed sufficient service. The squadron's role was Day Bomber, and the first Airco DH-9A biplanes arrived in March 1930. These First World War-era aircraft were a stopgap until the arrival of the Westland Wapiti in September 1930. Although it was a much newer aircraft, the Wapiti was a cheap and simple aircraft, using many of the components of the DH-9A that were available in abundance. It was powered by the Bristol Jupiter engine, so the ground crew that worked in the aero engine works were well acquainted with its maintenance.

Reservists were expected to attend in their spare time, usually twice a week. Weekend camps were held regularly, and included lectures and exams. Every year the squadron would have a two week summer camp, usually to Manston in Kent, involving intensive training in a chosen trade. In 1933, 501 was given the task of evaluating the new Westland Wallace, a derivative of the Wapiti, which was intended only for reserve squadrons. The Wallace had a longer fuselage and spatted wheels, although the spats were removed from some aircraft after an incident where a Wallace nosed-over during an emergency landing in a muddy field in November 1933.

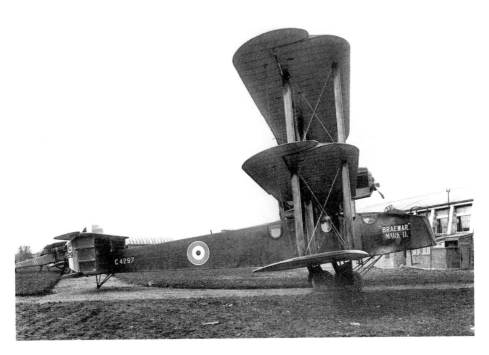

The Braemar triplane, designed towards the end of the First World War, was intended as a bomber that could reach Berlin. As no building in Filton Works was big enough, it was built in the AAP sheds and slid out sideways on rails. Only two were completed as there was no requirement for it after the Armistice. (Bristol Aero Collection)

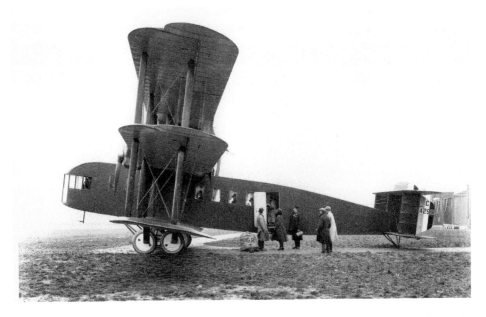

The Pullman was a development of the Braemar, and was one of the largest airliners in the world at the time. It first flew in March 1920, but did not go into production, as it was ahead of its time. It could carry fourteen passengers in relative luxury, including electric foot warmers at every seat! (Duncan Greenman via RRHT)

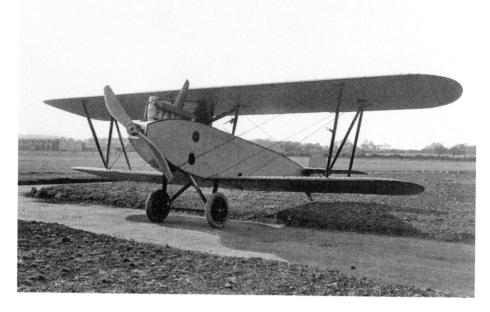

Development of a replacement for the Bristol Fighter, named the Badger, started in 1918. To test its flying characteristics, the Badger Experimental, or Badger X, was built, with the wings and tail of the Badger, but with a very basic box fuselage and Siddeley Puma engine. It flew on 13 May 1919, but was damaged nine days later and not repaired. (Bristol Aero Collection)

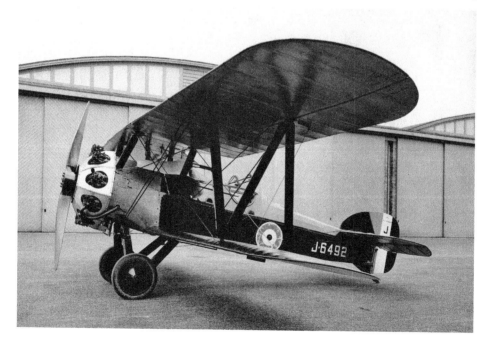

The sole Bristol Badger II, J6492, was powered by the Jupiter engine, a product of the Cosmos Engineering Company, which became the aero-engine division of the Bristol Aeroplane Company in July 1920. (Duncan Greenman via RRHT)

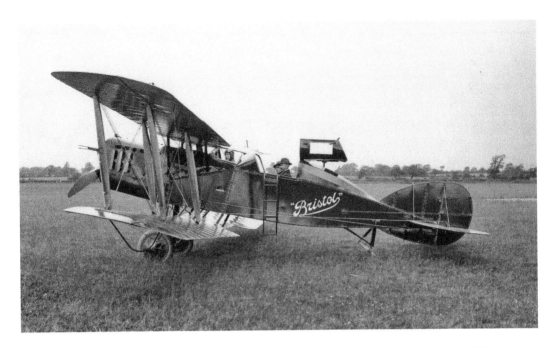

In peacetime, alternative uses for the Bristol Fighter were sought. The Tourer could carry two passengers side by side, and a number were fitted with a hinged coupé cover. This example was shipped to New York in August 1920, and others were sold in Spain, Bulgaria and Australia. (Bristol Aero Collection)

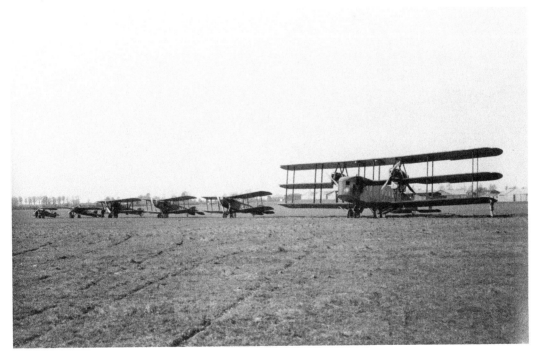

A line up of Bristol types around 1920. From left to right: Babe biplane, M.1C monoplane, Badger, Fighter, Tourer, Pullman. (Bristol Aero Collection)

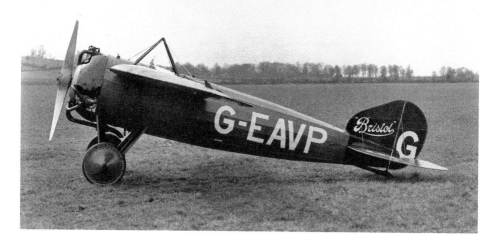

The sole M.1D Monoplane, G-EAVP, was a basic M.1B airframe with a 140 hp Bristol Lucifer engine fitted for racing competitions. Painted scarlet, it won the 1922 Aerial Derby Handicap, but crashed in 1923. (Bristol Aero Collection)

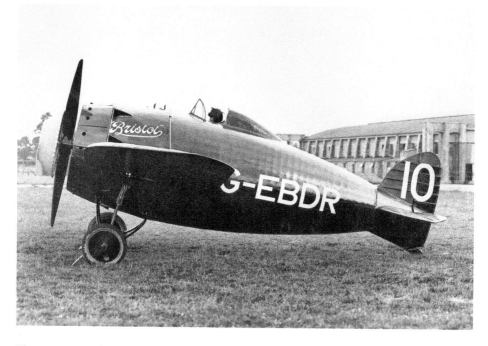

The 1922 Bristol Racer, nicknamed the Barrel Racer, was intended to demonstrate the power of the Bristol Jupiter engine. Although it used several new techniques such as a retractable undercarriage, it proved to be too unstable in flight and was abandoned after only seven flights. (Bristol Aero Collection)

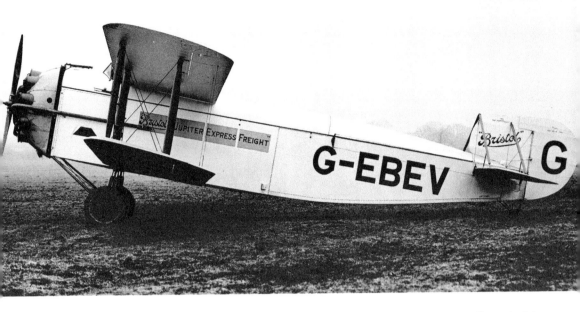

The Bristol Ten-Seater was another attempt to build a commercial transport. First flown in July 1922, it eventually saw service as a freighter with Imperial Airways, named the Jupiter Express Freight. (RRHT)

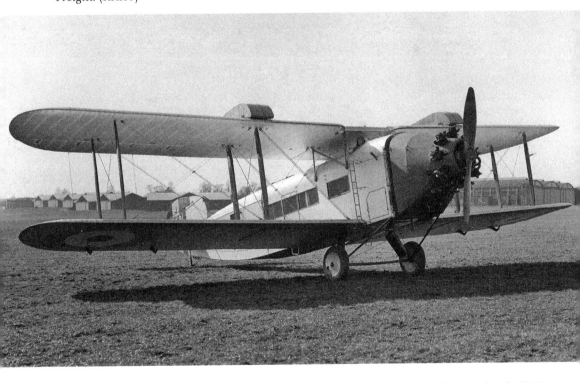

The Bristol Brandon, which first flew in March 1924, was intended as an ambulance for the RAF. However, it proved to be overweight and did not go into production. (RRHT)

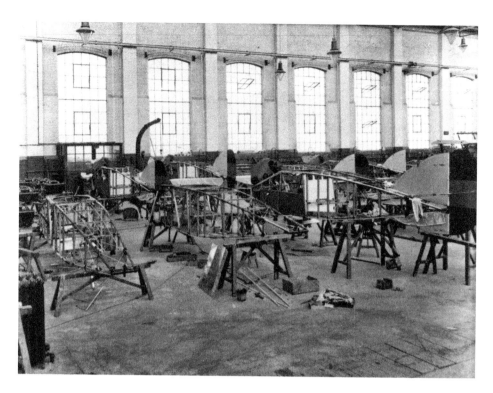

Bristol F.2B Fighters were still being built at Filton well into the 1920s. This batch was destined for the Spanish Air Force in 1924. (Duncan Greenman via RRHT)

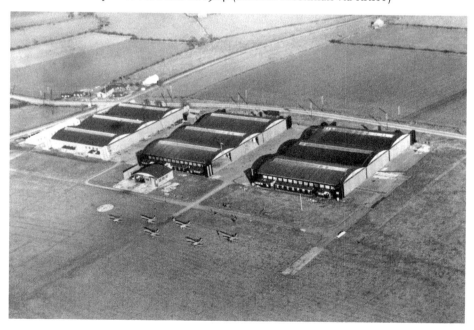

The Bristol Flying School opened in 1923, occupying the southernmost (right-hand) triple-span shed of the former AAP site. The aero-engine factory used the northern shed. (Bristol Aero Collection)

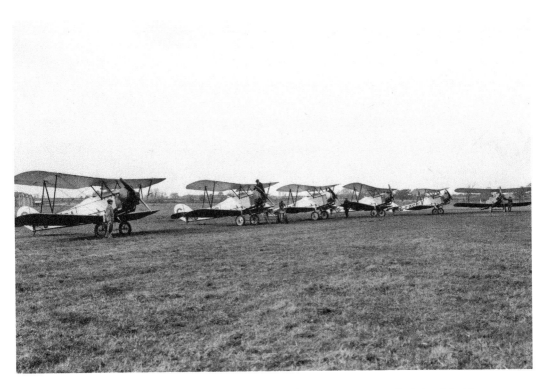

A line up of all six Bristol Lucifer Trainers (later known as Primary Training Machines or PTMs) of the Bristol Flying School, in November 1923. (Bristol Aero Collection)

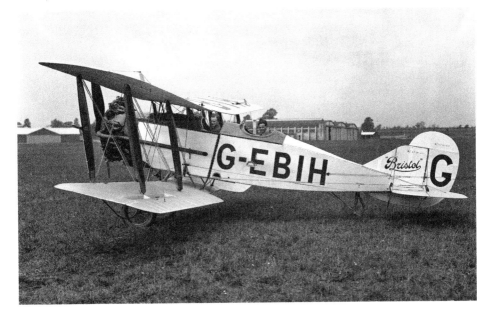

The Jupiter Training Biplane (later known as the Advanced Training Machine) was based on the Bristol Fighter design. The Bristol Flying School operated them from 1924 to 1935; this example, G-EBIH, was lost in a collision with a Lucifer PTM in 1929. (Duncan Greenman via RRHT)

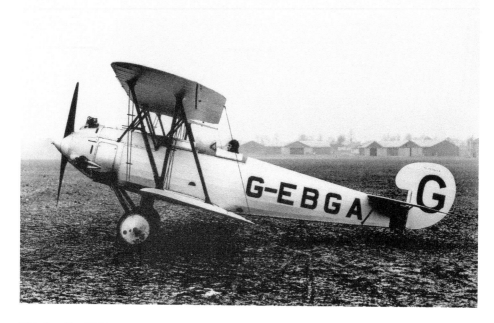

This Lucifer PTM, G-EBGA, was modified several times during its long career. It is shown here around 1928 with streamlined engine cowling, spinner and fuselage, and a much modified rudder. In this form it was also used for competition work. (Airbus)

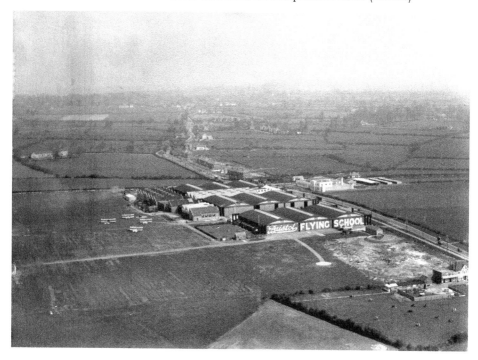

The Bristol Flying School and aero engine department around 1930, with three Lucifer PTMs and a Jupiter School on the grass. The white building across the Gloucester Road is the engine factory staff canteen. (RRHT)

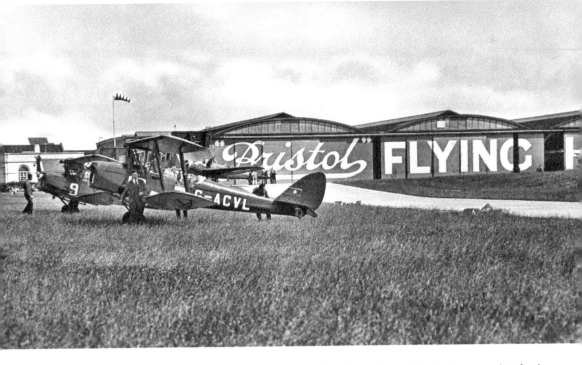

The Bristol Flying School re-equipped with de Havilland Tiger Moths in 1932. (Author's Collection)

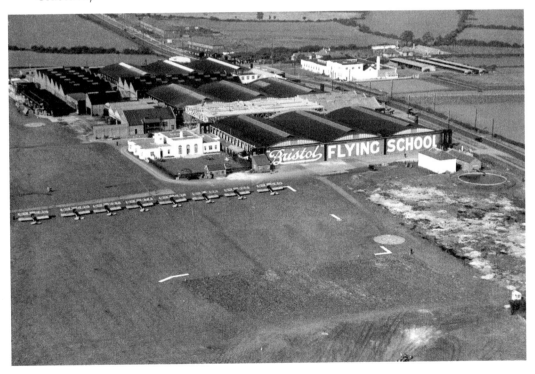

The aero-engine factory had swallowed two of the three 1917 general service sheds by the mid-thirties. The Bristol Flying School built offices alongside their hangar in 1933. A row of Tiger Moths is parked in front. (RRHT)

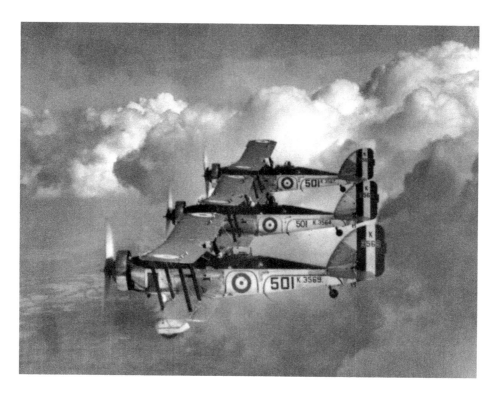

501 (City of Bristol) Squadron of the Special Reserve Air Force formed at Filton in 1929. These three Westland Wallace Is are in formation over Bristol in September 1933. (501 Squadron Association)

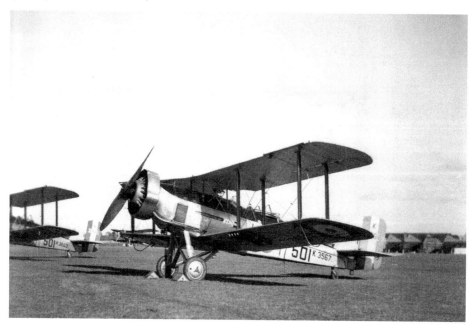

Westland Wallace K3567 of 501 Squadron at Filton in about 1934. (501 Squadron Association)

The Bristol Jupiter radial engine, inherited from Cosmos Engineering, was one of the most reliable engines of the time. Two Imperial Airways pilots flew this Bristol Bloodhound continually between Filton and Croydon from 2 January to 8 March 1926. The sign reads 'Bristol Jupiter Endurance Test, Finished 8-3-26, 25,074 miles, 225 hours 54 minutes, Without Replacements'. (Bristol Aero Collection)

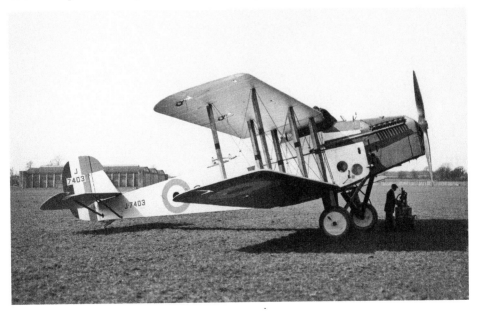

The Bristol Berkeley prototype first flew in March 1925. The Berkeley was the first Bristol aircraft to be given a type number, Type 90. Earlier types were allocated a number retrospectively, starting from the Scout C of 1914. (Bristol Aero Collection)

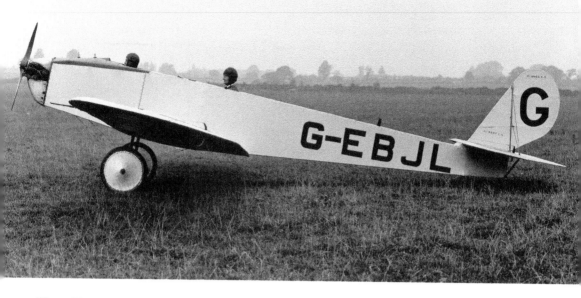

Three Type 91 Brownies were built for competition trials – G-EBJK, G-EBJL and G-EBJM – each given a nickname based on their registration – *Jack*, *Jill* and *Jim*. *Jill* was first flown on 22 September 1925, and was later operated by the Bristol and Wessex Aero Club at Filton. (Duncan Greenman via RRHT)

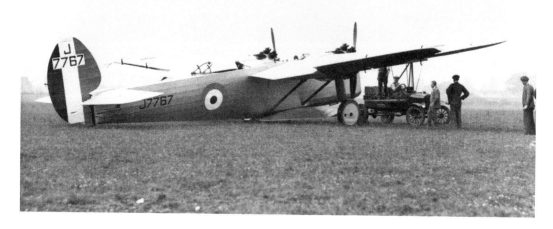

The Type 95 Bagshot, J7767, was built for an Air Ministry requirement for a three-seat fighter carrying two shell-firing cannons. It flew in July 1927, but its semi-cantilever wings caused problems at high speed and the project was abandoned. Note the Hucks Starter parked nearby, which was used to rotate the propeller to start the engine. (Duncan Greenman via RRHT)

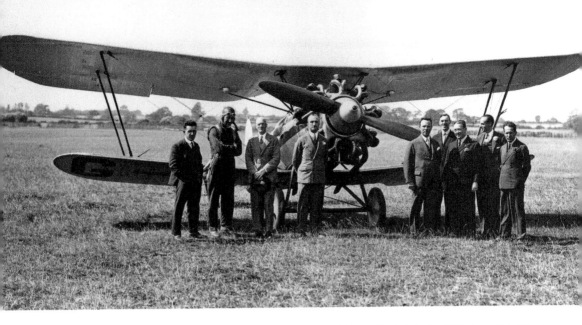

A Bulldog company demonstrator around 1929. Second from the left is Cyril Uwins, Chief Test Pilot, and third from the left is Frank Barnwell, designer of the Bulldog and many other Bristol aircraft. (RRHT)

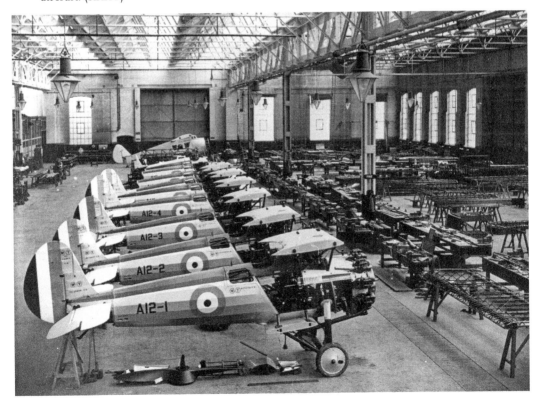

A row of Bulldogs destined for the Royal Australian Air Force. All eight were delivered by ship in early 1930. (Duncan Greenman via RRHT)

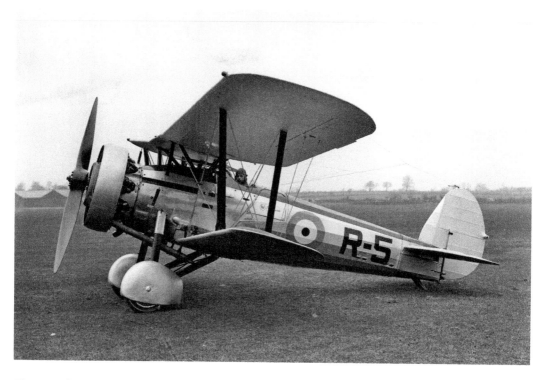

The Bristol Mercury-powered Bulldog III prototype in late 1931, carrying Bristol test marks R-5. (Bristol Aero Collection) (G2831)

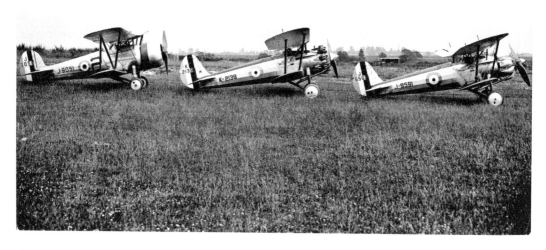

Three similar models of the Bulldog in 1931, each with different engine cowlings. From left, Bullpup J9051 with short-stroke Mercury and long-chord cowling; Bulldog IIA K2139 with standard Jupiter engine; and Bulldog II J9591 with Mercury IV and helmet cowling. (Duncan Greenman via RRHT)

34

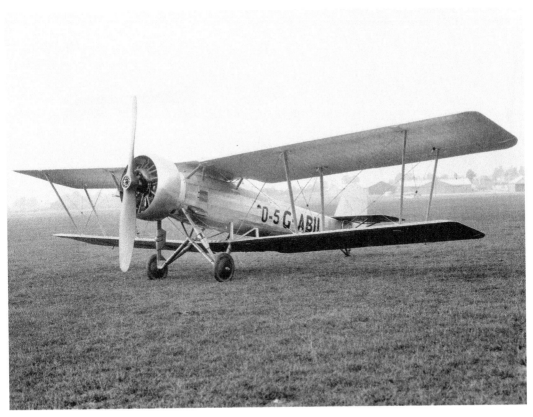

Above: Cyril Uwins set the world altitude record on 16 September 1932, on a flight from Filton. The aircraft was this Vickers Vespa, G-ABIL, powered by a production Bristol Pegasus. (RRHT)

Right: The Vickers Vespa over the Severn Estuary. Note the eastern end of the Severn rail tunnel at bottom right. (RRHT)

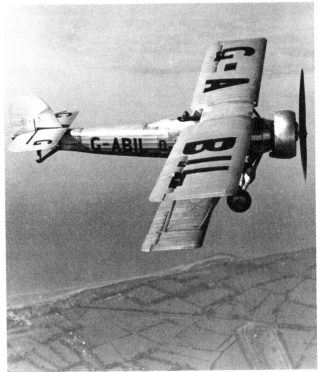

Although an elegant aeroplane in appearance, the Rolls-Royce Goshawk-engined Type 123, Bristol's last biplane, was very unstable in flight. Development was abandoned after only a few flights in 1934. (Duncan Greenman via RRHT)

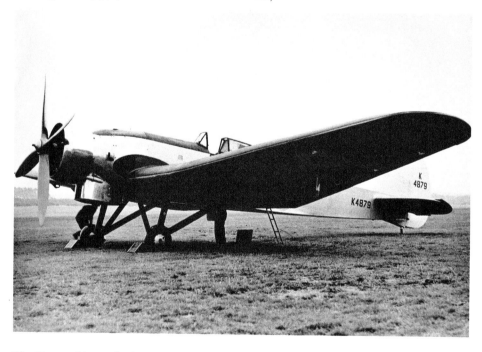

The Type 138A was built in 1936 to take back the world altitude record, which had been broken twice since Uwins' attempt in 1932. The aircraft broke the record on 28 September 1936 with a height of 49,967 ft, and again on 30 June 1938 with 53,937 ft. (Duncan Greenman via RRHT)

CHAPTER 3

The Expansion

By the mid-1930s, tensions were rising in Europe, and a massive expansion of Britain's military capability was underway. New factory sites were constructed – Rodney Works, between Filton Works and the airfield, and East Works, across the Gloucester Road from the former AAP sheds, which became West Works. By the outbreak of war the Filton site was the largest aircraft factory in the world. Manufacturing work was also assigned to shadow factories, which were predominantly car factories elsewhere in England. The airfield doubled in size with the acquisition of land to the north of Hayes Lane, which was closed to allow for a north/south take off run in addition to the east/west grass runway. These grass runways were replaced with concrete ones in December 1941.

501 became an Auxiliary Squadron in 1936; it was renamed No. 501 (County of Gloucester) (Bomber) Squadron to cover a wider area. In July 1936 it began re-equipping with the Hawker Hart, which was subsequently replaced by the Hawker Hind. The Bristol Flying School now began training regular pilots for the RAF as well as reservists. The school offered an eight week course including fifty hours of flying, as well as ground instruction. In 1936 a second school was set up at RAF Yatesbury, and with the creation of the RAF Volunteer Reserve in 1937, the Filton school was renamed No. 2 Elementary and Reserve Flying Training School (2 ERFTS). By August 1940, the introduction of barrage balloons meant that training was becoming extremely difficult, and 2 ERFTS moved north to RAF Staverton.

In early 1939, 501 Squadron's role was changed from bomber to fighter and it was given the motto *Nil Time*: Fear Nothing. The first Hurricanes arrived in March 1939, and it was not long before the call-up came and the squadron became a full time unit in the Royal Air Force. The squadron expanded further and began patrols of the Bristol Channel. War was declared on 3 September, and in December the squadron relocated to Tangmere in Sussex. Six months later, with the invasion of the Netherlands, Belgium and France by German forces, 501 moved to France, and into the front line of the Second World War.

263 Squadron formed at Filton on 2 October 1939, with the role of defending Bristol and South Wales, equipped with Gloster Gladiator biplanes. Most of the pilots were fresh from training schools, but the squadron was deemed to be ready to take on the protection of the area by late November. They mainly performed training exercises, using Sand Bay near Weston-super-Mare as a shooting range, and intercepted the occasional German aircraft. The squadron left Filton on 20 April 1940, following the invasion of Norway. 236 Squadron moved to Filton in May 1940, tasked with patrols over the English Channel using Bristol Blenheims. Their stay was brief, moving to Thorney Island in July 1940. This left Filton with no RAF aircraft; the only defences in the area were barrage balloons and anti-aircraft guns.

The first German air raids over the West Country did not occur until 19 June 1940. Many of the early raids were made by a single aircraft, at night, and usually did not reach their

intended target. The raid on 19 June was by a single Heinkel He111, which only made it as far as Portishead before returning to France. Over the next few months however, the Luftwaffe intensified its raids on Britain, with the aim of decimating British air defences in advance of an invasion. As such, the prime targets were RAF airfields in South East England. Bristol's own 501 Squadron, now based at Gravesend in Kent, was a significant part of the air defence in these attacks. In mid-September, Hitler abandoned his plans to invade Britain and instead focused on the British aircraft industry, with large scale daytime raids. The first attack took place on 25 September 1940 and Filton was the target.

Between 9 a.m. and 9.30 a.m. on that morning, three *Gruppen* of Kampfgeschwader 55 (KG55) took off from bases near Paris, and flew north-west towards a rendezvous point at Cherbourg. By the time they arrived over the French coast, at 11 a.m., the three *Gruppen* had combined to form a giant *Geschwaderkeil* formation, totalling sixty-four Heinkel He111 bombers. Here they met up with their protection, around fifty Messerschmitt Bf110 fighters that would defend the formation from behind and above. Decoy raids were also taking place against Portland, Portsmouth and Plymouth.

Radar was in its infancy at this time, and the scale of the incoming force was not realised until the formation reached the English coast line. RAF fighters were scrambled to meet the attack and squadrons of Hurricanes and Spitfires quickly flew towards Portland, expecting the formation to be the second wave of the earlier attack, but were too late to intercept the aircraft. On reaching Weston-super-Mare, the formation turned north-east towards Filton.

At Filton, the employees at the factories were used to air raid sirens, which occurred several times a day, but they knew to leave their work stations when 'Marching Through Georgia' was played over the tannoy. As some were still making their way to the air raid shelters, at 11.48 a.m., the formation began dropping its bombs on Filton. In under a minute, the Heinkels had dropped around 350 bombs, causing devastation below. It is thought that around 160 people lost their lives as a result of the raid, mostly within the factory grounds. Six shelters took a direct or very near hit; these either caved in, burying those inside, or left large craters. Miraculously, there are stories of some lucky individuals who were thrown out of the shelters by the blast and survived.

The German media hailed the raid as a success, and claimed that the factory was shut down for good. In fact, much of the factory was relatively unscathed, and production was quickly back on track. Only eight Bristol Beaufighters were destroyed in the aircraft factory. As a response to the raid, defences at Filton were immediately increased, and Hurricanes of 504 Squadron were transferred from Hendon the following afternoon. This proved to be a timely move, as a raid on the area the next day was successfully thwarted by 504 Squadron, with no bombs dropped.

Battle weary 501 Squadron returned to Filton on 17 December 1940, replacing 504, which moved to Exeter. In the preceding six months 501 had fought valiantly in the Battle of France and the Battle of Britain. The second highest scoring Fighter Command ace in the Battle of Britain was a 501 pilot, James 'Ginger' Lacey.

118 Squadron formed at Filton on 20 February 1941, flying the Spitfire Mk I, to carry out convoy patrols. Both 118 and 501 squadrons relocated to Colerne in Wiltshire in April 1941. They were replaced on 10 April with the return of 263 Squadron, which was the first squadron

to be equipped with the Westland Whirlwind. 263 moved to RAF Charmy Down near Bath on 7 August. The last RAF Squadron to be based at Filton during the Second World War was 528 Squadron, which formed at Filton on 28 June 1943. Its task was radar calibration, using Bristol Blenheims and de Havilland Hornet Moths. 528 moved to RAF Digby in May 1944 and was merged with 527 Squadron six months later.

In late 1943, in preparation for Operation Overlord, the invasion of German-occupied France, a massive expansion of American forces was underway. Under the name Operation Bolero, large numbers of aircraft were shipped across the Atlantic to British ports, including Avonmouth. A small tented community was built on the fields to the north-west of the RAF base at Filton, and the first of four Butler combat hangars was erected on 7 December. Named XI Base Aircraft Assembly Depot (or XI BAAD, and later just BAAD) it comprised three units – 21st, 22nd, and 33rd Mobile Reclamation and Repair Squadrons (MR&RS). The site was given a much needed improvement in January 1944 with the addition of gravel hardstandings, running water, and electricity. The first American aircraft arrived at Filton from two ships at Avonmouth on 31 December, comprising fourteen P-47 Thunderbolts and eleven P-51 Mustangs.

Larger aircraft were shipped complete as deck cargo, with extraneous parts such as outer wings, tails and propellers removed. Communication and trainer aircraft like the AT-6 Texan and UC-64 Norseman arrived dismantled in crates. They were transported at night along the Portway, through the city and up the Gloucester Road to Filton on low-loaders. The complete aircraft were cleaned of their protective coating of waxy Cosmoline – a particularly dirty job – reassembled and test flown from the airfield. They were then ferried to one of the local Tactical Air Depots (TADs) for inspection and fitting of any specialised equipment before being delivered to squadrons of the Ninth Air Force, based in Britain at the time. After D-Day on 6 June 1944, American aircraft were shipped straight to the Continent, and the Americans moved out in mid-June. Sadly, 16 men were injured on 16 June when one of the Butler hangars collapsed during dismantling. In all, over 500 US aircraft were processed by BAAD over six months.

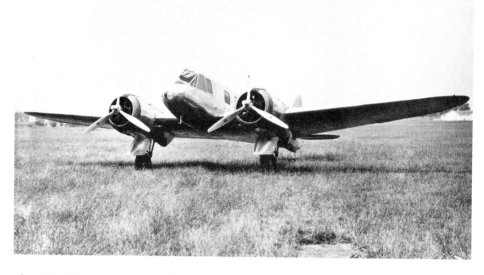

The Bristol Type 142 was a high-speed passenger aircraft, first flown in April 1935. Only one was built, for Lord Rothermere, proprietor of the *Daily Mail*, who nicknamed it *Britain First* and promptly handed it over to the military for trials. It proved to be substantially faster than the latest RAF fighters. (Author's Collection)

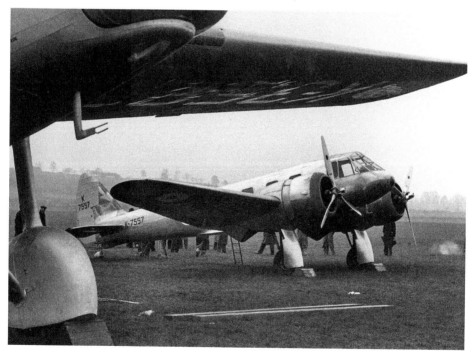

The Bristol Type 142, behind the prototype Bristol Bombay. The 142 led to a family of twin-engined military aircraft, the Blenheim, Beaufort, Beaufighter, Buckingham and Brigand, making it the most important aircraft designed at Filton. (RRHT)

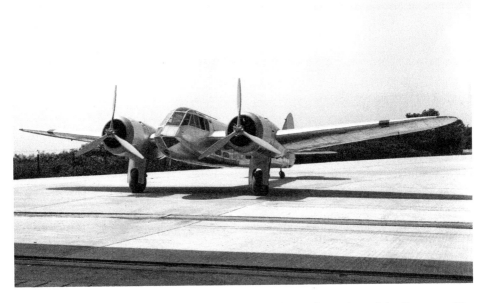

The Type 142M, named the Blenheim I, was the military derivation of the Type 142. The wings were raised to the centre of the fuselage to allow for a bomb bay underneath. A bomb aimer sat in the glazed nose, and a gunner occupied a turret towards the rear. The first Blenheim is seen here at Filton in June 1936. (Duncan Greenman via RRHT)

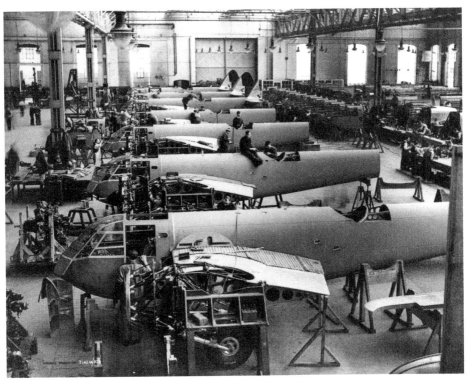

Blenheim Is under construction at Filton. (DG)

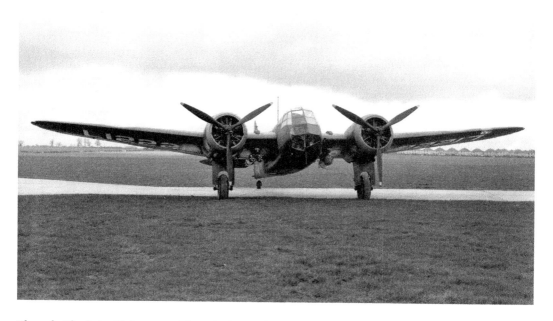

The sole Blenheim II, L1222, at Filton in September 1938. It was used to develop the increased fuel capacity and strengthened undercarriage required for the Blenheim IV. The houses on Callicroft Road are visible in the distance. (Author's Collection)

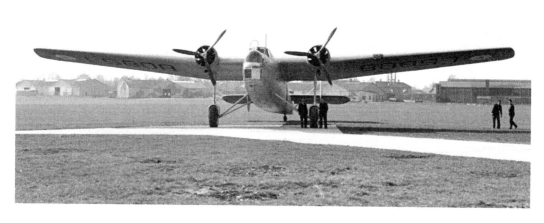

The first production Type 130 Bombay troop carrier at Filton in 1939. Although the prototype was built at Filton, all production Bombays were built by Short & Harland in Belfast, as Filton was fully resourced to Blenheim production. (Author's Collection)

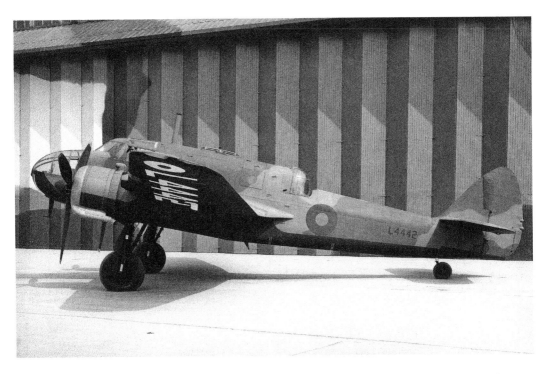

The second Type 152 Beaufort, L4442, outside No. 1 Flight Shed of Rodney Works in early 1939. Rodney Works were built during the 1936 expansion, and much of the site was demolished in 2005, although No. 1 Flight Shed still survives. (Bristol Aero Collection)

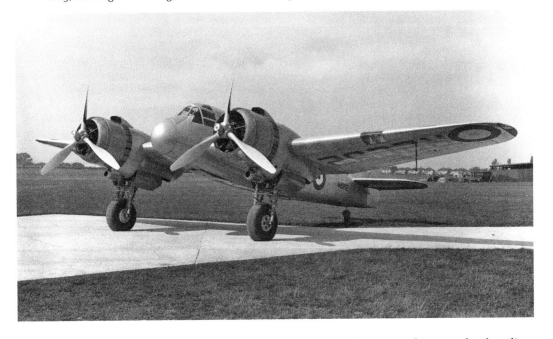

The prototype Type 156 Beaufighter I, R2052, at Filton in July 1939. At this stage the clean lines of the aircraft were not disfigured by the armament it was designed to carry. (Duncan Greenman via RRHT)

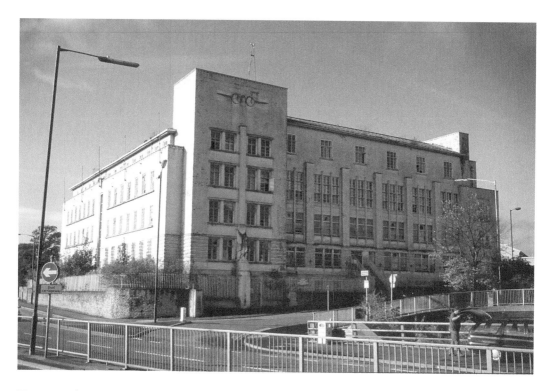

Now named Pegasus House, New Filton House was built in true Art Deco style in 1936, coinciding with the massive expansion of the factory in the build-up to war. The tower in the north-west corner added to its prominence at the top of Filton Hill.

This photograph from 2001 shows it as complete but in a sad state. It was covered in sheeting in 2006 to prevent further damage, and there are plans to restore it to its former glory as part of the planned Aerospace Park. (Author)

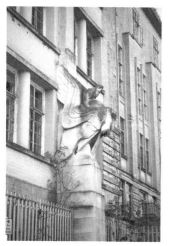

The building has several interesting features, paying homage to the factory and its significance in British aviation. These photographs from 2001 show the Pegasus sculpture on the north side of the tower, carved from Portland stone by Denis Dunlop, and the relief of the Type 142, *Britain First*. (Author)

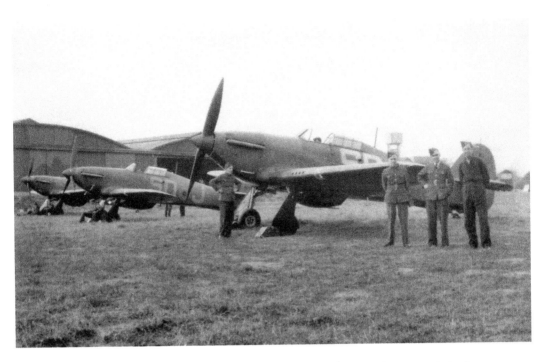

Hurricanes of 501 Squadron lined up at Filton in 1938. (501 Squadron Association)

Crew from 501 Squadron pose in front of a Hurricane in September 1939. At the outbreak of war, B Flight were allotted a dispersal site in the north-east corner of the airfield. A garage now exists on this spot. (501 Squadron Association)

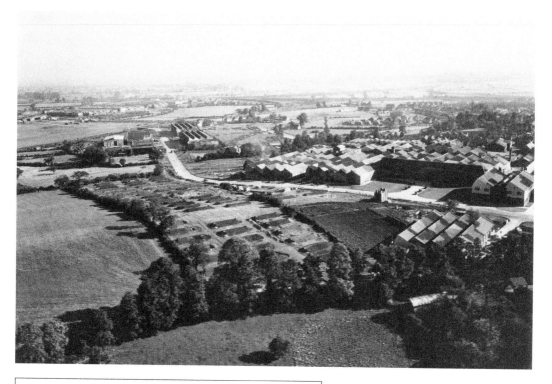

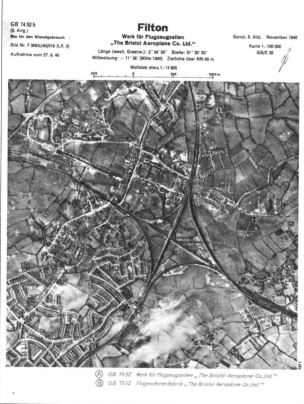

GB 74 52 b
(2. Ang.)
Nur für den Dienstgebrauch .
Bild Nr. F 908b/40/016 (Lfl. 3)
Aufnahme vom 27. 9. 40

Filton
Werk für Flugzeugzellen
„The Bristol Aeroplane Co. Ltd."
Länge (westl. Greenw.): 2° 34′ 30″ Breite: 51° 30′ 50″
Mißweisung: — 11° 36′ (Mitte 1940) Zielhöhe über NN 65 m
Maßstab etwa 1 : 14 600

Genst. 5. Abt. November 1940
Karte 1 : 100 000
GB/E 32

(A) GB 74 52 Werk für Flugzeugzellen „The Bristol Aeroplane Co. Ltd."
(B) GB 73 52 Flugmotorenfabrik „The Bristol Aeroplane Co. Ltd."

Above: In 1940, when 'Marching Through Georgia' was played on the tannoy in the factory, the workers knew they had so many minutes to get to the air raid shelters, some of which are in the foreground. Despite attempts to disguise the factory with camouflage paint, the nearby intersection of railway lines made it easy for the Luftwaffe to find the airfield. This view is looking north-east. (Author's Collection)

Left: This German document contains a photograph taken by a Luftwaffe reconnaissance aircraft on 27 September 1940, two days after the devastating air raid. It shows the aircraft factory (A), the aero engine factory (B) and the airfield itself (1081). Just visible are the bomb craters left behind by the raid. Attempts were made to disguise the airfield by laying lines of ash to give the appearance of fields. (Bristol Aero Collection)

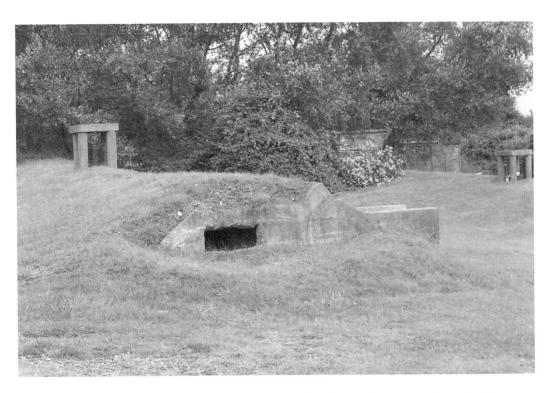

One of several air raid shelters that survive within the factory. The entrance is to the right; the hole in front has been added at a later date. (Author)

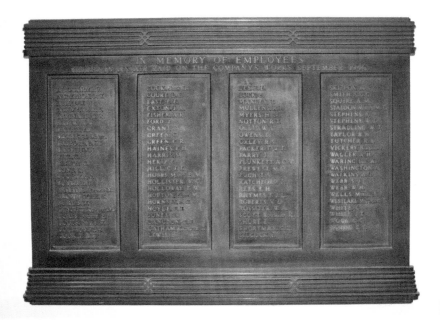

This plaque, which lists the names of the factory employees who were killed in the Luftwaffe raid on 25 September 1940, was originally mounted in New Filton House. It is now in Filton church, across the road. (Author)

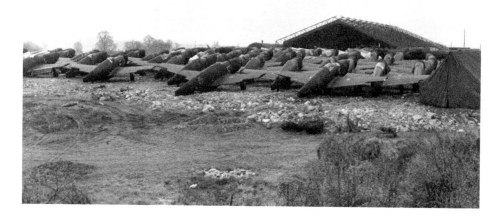

At the end of 1943 Filton became USAAF Station #803. P-51 Mustangs and P-47 Thunderbolts were shipped to Avonmouth Docks and transported to Filton, where they were cleaned, reassembled and flown out to USAAF 9th Air Force squadrons. (US National Archives and Records Administration)

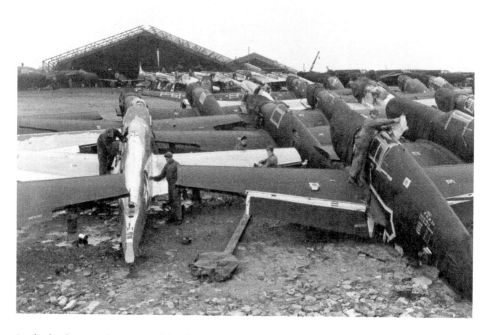

In the background are two of the four Butler Combat Hangars built at Filton. These lattice frame structures were lined internally with a thick canvas, and designed to be transportable. (US National Archives and Records Administration)

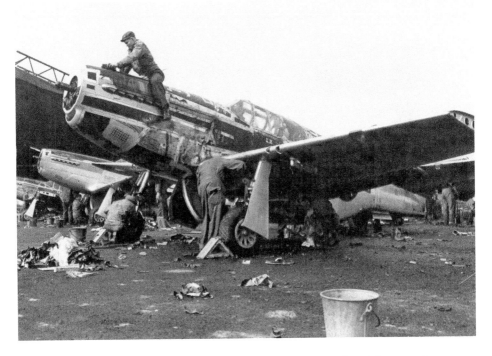

The job of removing the protective grease and Cosmoline was a dirty job, as can be seen on this P-51B Mustang. (US National Archives and Records Administration)

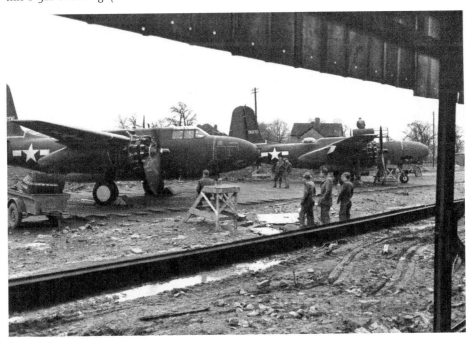

In addition to P-51 Mustangs and P-47 Thunderbolts, several A-20 Havocs and P-38 Lightings were prepared at Filton. These photographs were taken on 20 May 1944, only seventeen days before D-Day. (US National Archives and Records Administration)

CHAPTER 4

Post War

In 1942, a government committee, led by Lord Brabazon of Tara, was set up to determine what commercial aircraft Britain should build after the war. Five types were outlined, increasing to eight by 1945. The one that was deemed most important was an airliner that could fly from London to New York non-stop. The Bristol Aeroplane Company was awarded the contract, based on their design for a 100-ton bomber. Work on a new Aircraft Assembly Hall (or AAH, later nicknamed the Brabazon Hangar) started in 1946 to the west of the aircraft factory. This massive structure was the biggest of its kind in the world. It comprised three separate bays, 117 feet high at each apex, with concertinaed doors that ran the entire 1,052 foot length of the building. The structure had a large expanse of glass along its northern side to let in natural light; this was later lost when the building was re-clad in the 1980s. The doors opened onto a seven-acre apron to the south, cut into the side of the hill, and a taxiway was built leading to the main runway. This included a level crossing over the Avonmouth railway line, a unique feature in the UK.

At the same time, a new strengthened east/west runway was built, which extended the existing 4,500-foot-long runway westwards to over 8,100 feet. In addition, the width was doubled to 300 feet. The western extension severed the Filton by-pass dual carriageway, which was less than a decade old. However, more destructive was the complete demolition of the village of Charleton, save for a couple of buildings that were outside of the runway's path. The new runway was completed in 1948.

Construction of the first Brabazon aircraft was started in an erecting hall within the existing factory site. The AAH East Bay was the first in service, and the partially completed Brabazon fuselage was towed through the site to its new home in December 1947. In the same year, BOAC was looking to relocate its maintenance base at Dorval in Canada to the UK. This specialised in the servicing of American-built types, such as the Lockheed Constellation. Filton was deemed to be the only suitable place in the UK, pending the construction of facilities at Heathrow. It was agreed that the AAH West Bay would be handed over to BOAC when it was complete. The Ministry of Civil Aviation accepted the possible delay to the Brabazon project, and preparation work started in April 1948. This included the construction of workshops and the installation of a new instrument landing system (ILS). Lockheed Constellations appeared later in 1948, and in 1949 Boeing Stratocruisers were regular visitors to the airfield. BOAC moved out in 1954, when its Heathrow base was ready.

The Brabazon Mark I prototype made its first flight on 4 September 1949. The prototype was used to test the new technology required for such a large aircraft in regular service. In this respect it was successful, but the availability of cheaper American aircraft meant that the project was ultimately abandoned and the aircraft scrapped in late 1953. Alternative uses for

the AAH were found even before the Brabazon was scrapped. In 1951 and 1952, over eighty ex-USAF Boeing B-29 bombers were converted for RAF use as the Washington B.1. Construction of the Bristol Britannia airliner took place in the AAH and the prototype first flew in 1952. A production run of eighty-five Britannias kept the AAH occupied until 1960.

501 Squadron returned to Filton for the third time on 10 May 1946, this time with the reinstatement of the Royal Auxiliary Air Force on a post-war footing. The squadron was re-formed as a fighter squadron, equipped with the Spitfire LF.VXIe, the first of which arrived in November. The squadron moved into the jet age in 1948 when the Spitfires were replaced with Vampire F.1s, and subsequently Vampire FB.5s in 1951. Due to defence cuts after the Suez Crisis in November 1956, it was announced that the Royal Auxiliary Air Force was to be disbanded, and 501 was officially grounded on 10 January 1957. An emotional disbandment parade was held on 3 February 1957, marked by a flypast by the squadron adjutant in a Vampire. The parade was marred by tragedy when one of 501's pilots, Flight Officer John Crossley, was killed. He had illegally taken a Vampire up shortly before the parade, and flown under the Clifton Suspension Bridge, the only jet aircraft ever to do so, and almost immediately crashed into Leigh Woods.

The training role of the airfield resumed with the formation of two successors to the pre-war Bristol Flying School. No. 12 Reserve Flying School, operated by the Bristol Aeroplane Company under contract to the Air Ministry, was formed in 1947, and the Bristol University Air Squadron, which was intended to attract graduates to the RAF, was formed in 1950.

In the late 1950s, when tension between the Western allies and the USSR was at its peak, it seemed to many that nuclear war was inevitable. Britain had a nuclear deterrent in the form of its V-Bomber force, Vulcans, Victors, and Valiants, which would be airborne within four minutes of receiving an alert. Filton was designated one of twenty-six V-Bomber dispersal sites in the UK. The dispersal of the fleet would mean that Britain would still have a nuclear capability even if the main V-Bomber bases were targeted. Around 1958 an Operational Readiness Platform (ORP) was laid to the east of the RAF base, comprising four parallel parking bays. A taxiway straight to the start of the eastern end of the runway was also built. At times, two Vulcans were parked at Filton, fully fuelled and with ground power running, ready for the alert.

In 1956, the Bristol Aeroplane Company was divided into three subsidiaries – Bristol Aircraft, Bristol Aero-Engines, and Bristol Cars. In 1959, Bristol-Siddeley was formed when Bristol Aero-Engines merged with Armstrong-Siddeley. The aircraft factory then merged with English Electric and Vickers the following year to become British Aircraft Corporation Filton Division.

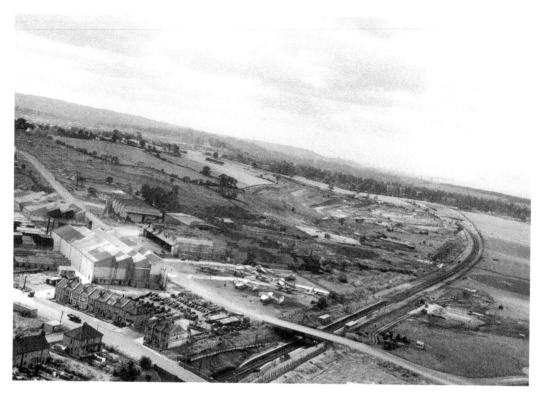

This 1946 view looking west shows the flight sheds in Rodney Works, which still survive. In the distance, construction of the Aircraft Assembly Hall (AAH) is beginning. (Bristol Aero Collection)

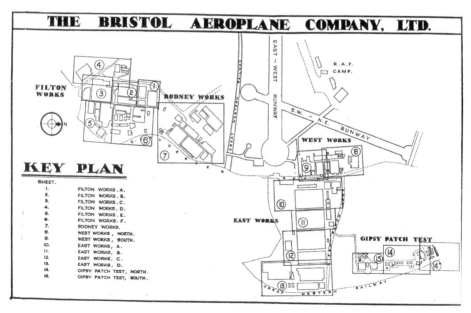

A post-war diagram showing the main factory sites around the airfield. The AAH is not shown. (RRHT)

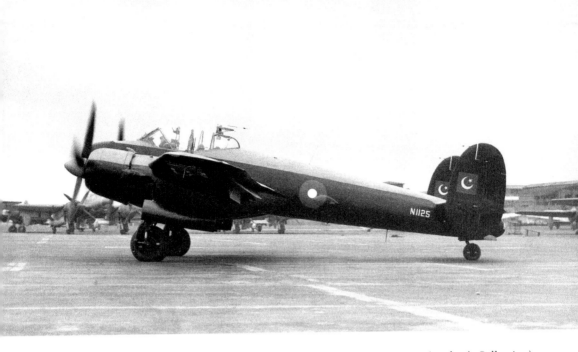

Brigand N1125 was delivered to the Pakistan Air Force in January 1949. (Author's Collection)

The prototype Bristol 170 Freighter on 30 November 1945, three days before its first flight. (RRHT)

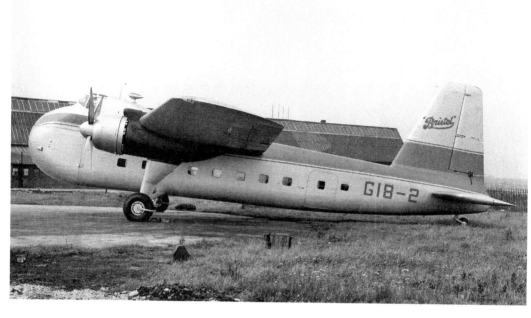

The third Bristol 170 undertook a gruelling five-month sales tour of North and South America in 1946, took part in the Berlin Airlift in 1948, and became the Mk 21 prototype in 1949. (Bristol Aero Collection)

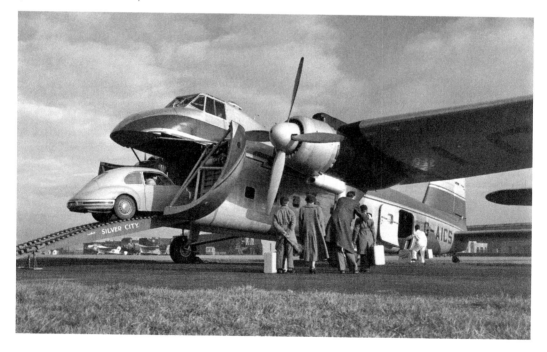

A promotional photograph showing a Bristol 401 car being loaded into a Freighter. Note the Brigand and Buckmaster aircraft in the background, outside West Works. (Bristol Aero Collection)

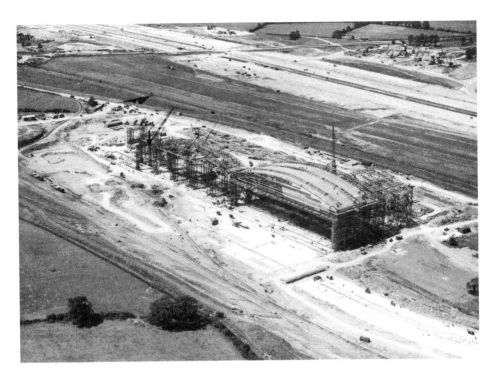

Construction of the AAH and the runway extension work underway in 1946. The Filton Bypass road was severed by the new runway, and the village of Charleton was demolished. (Bristol Aero Collection)

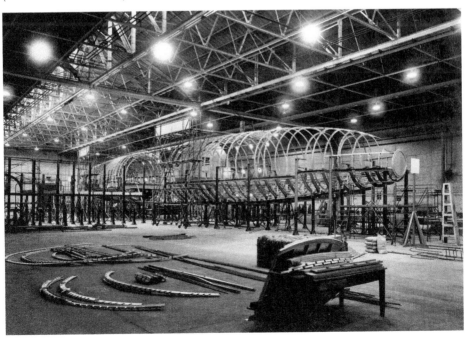

The Brabazon I takes form, sometime in late 1945 or early 1946. Assembly was started in No. 2 Flight Shed while the AAH was under construction. (Bristol Aero Collection)

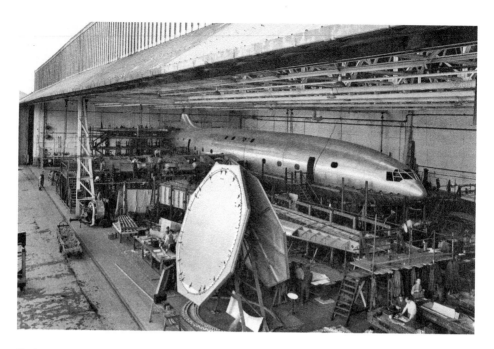

Brabazon I coming together in No. 2 Flight Shed. (Bristol Aero Collection)

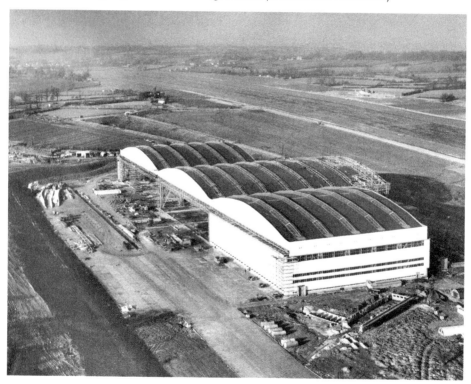

The AAH has three bays – West, Centre and East. The first to be completed was East Bay. The height of each bay is 117 feet at the apex, and the entire hall is 1,052 feet long. The centre bay is 420 feet deep and the two 'half' bays are 270 feet deep. (Bristol Aero Collection)

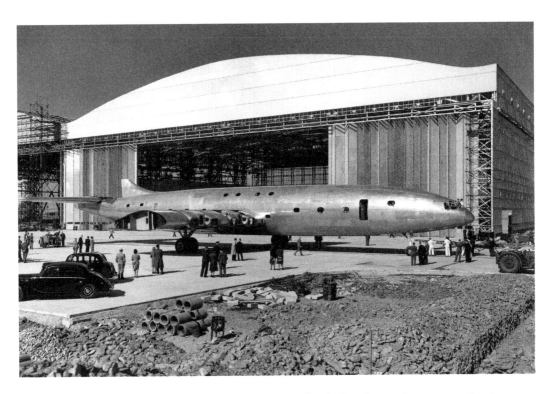

The incomplete aircraft was towed from No. 2 Flight Shed to the AAH apron on 4 October 1947, when the East Bay was ready to accept it. (Bristol Aero Collection)

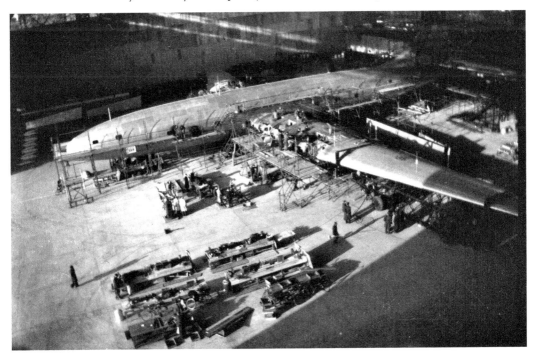

The prototype Brabazon I being worked on in the AAH in 1948. (Author's Collection)

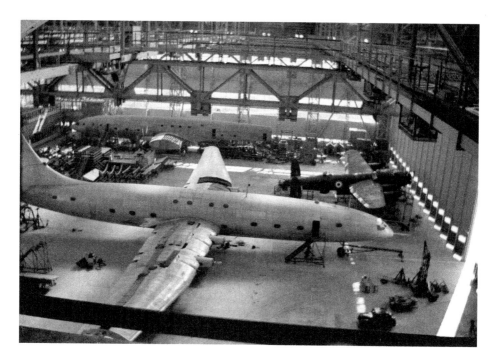

The Brabazon I nearing completion, with the Brabazon II fuselage and a Lancaster behind. The Lancaster was used to test a number of features, such as the hydraulic elevators. (Author's Collection)

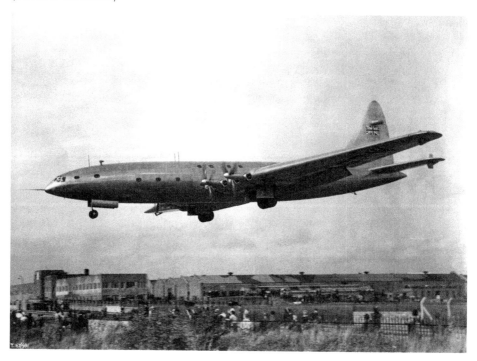

The Brabazon coming into land at Filton after its first flight on 4 September 1949. (Bristol Aero Collection)

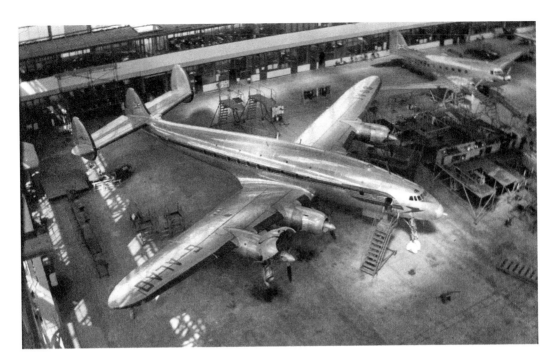

From 1948 to 1954 BOAC leased the West Bay as a maintenance base for their American-built fleet. Lockheed Constellation G-ALAO is being worked on next to Douglas DC-3 G-AGKB. (Author's Collection)

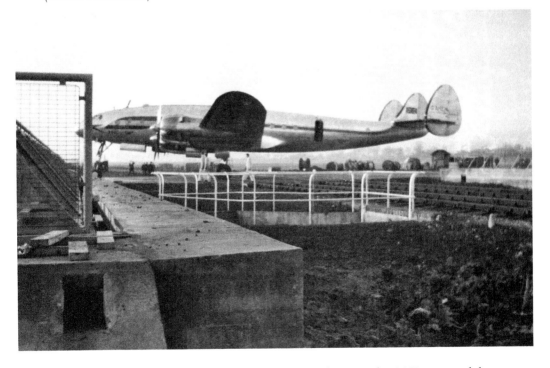

Lockheed Constellation G-AHEM on the level crossing between the AAH apron and the runway. The level crossing is a unique feature of Filton Airfield. (Author's Collection)

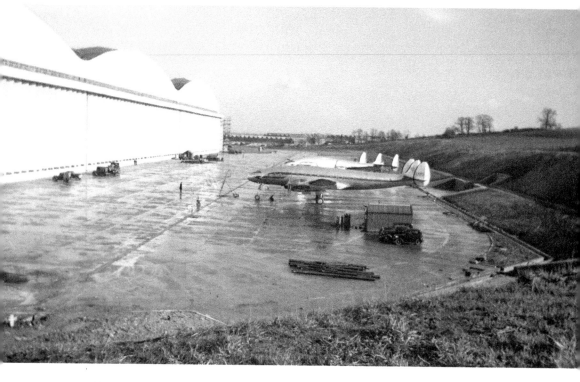

Two Constellations on the seven-acre apron outside the AAH. (Author's Collection)

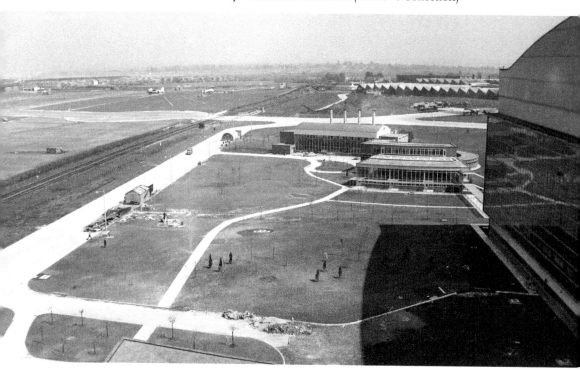

View looking east from the AAH centre bay roof around 1949, over the new boiler house and canteen towards Rodney Works. The level crossing over the railway line is visible. (Author's Collection)

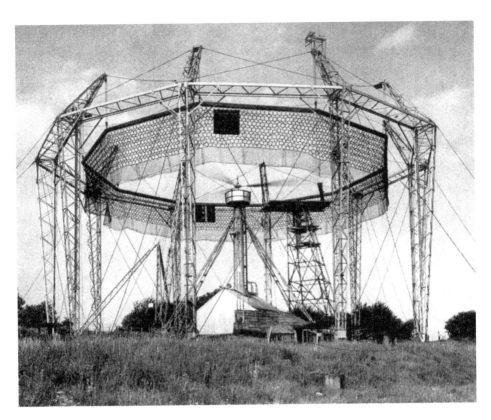

The Rotor Spinning Tower was built in 1947, and was a landmark for several years. It was 50 feet high, and could take rotors with a diameter up to 60 feet. It was surrounded by 70-foot-high pylons, on which was mounted a height-adjustable ring of protective netting. (RRHT)

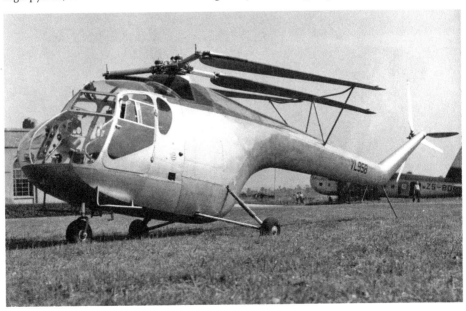

The prototype Type 171 Sycamore made its first flight on 27 July 1947. It was the first British helicopter to be certified. (Bristol Aero Collection)

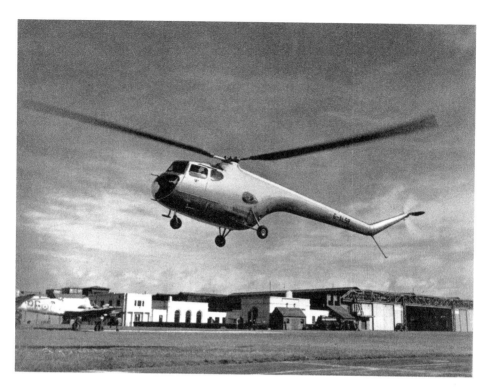

G-ALSR, the first Sycamore Mk 3, landing in front of the West Works around 1951, with a Beaufighter behind. (From a BAC Brochure)

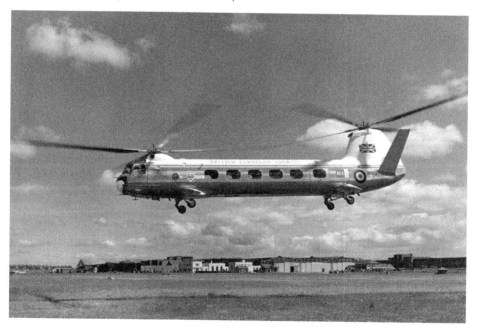

The second prototype Type 173 twin rotor helicopter was loaned to British European Airways for trials in August 1956. It was also used by the Royal Navy for carrier trials, hence the hybrid markings. (Author's Collection)

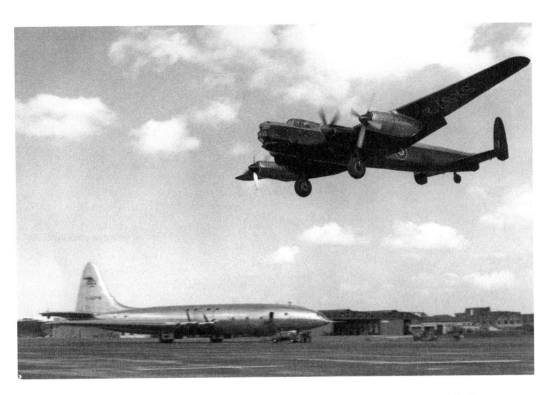

The Avro Lincoln test bed on short finals at Filton in December 1950. The aircraft had a pair of Bristol Proteus turboprop engines in the outboard positions. (RRHT)

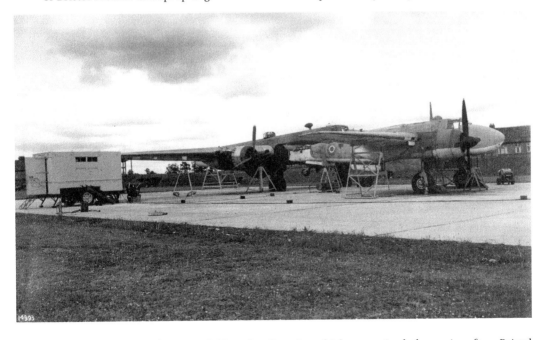

This contraption is the Bristol Hercules fire rig, which comprised three aircraft – Bristol Buckingham KV419 at the front, and a Halifax fuselage fitted with the wing from a Hastings at the rear. (RRHT)

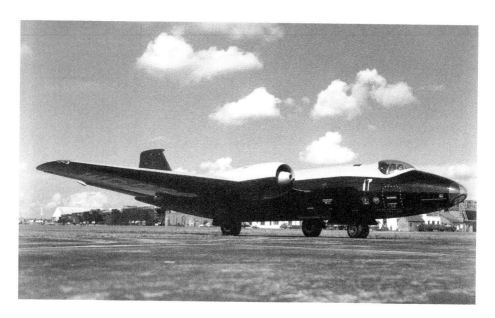

Canberra WD952 was used as the Bristol Olympus test bed in the early 1950s. On 4 May 1953, Walter Gibb set a new world altitude record in the Canberra by reaching 63,668 ft in a flight from Filton. He broke his own record two years later in the same aircraft with a height of 65,876 ft. (RRHT)

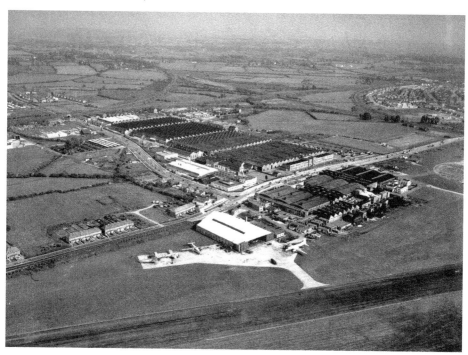

The aero engine factory around 1955, with the north-east/south-west runway in the foreground. Visible outside the engine hangar are the Hercules fire rig, the Airspeed Ambassador test bed for the Proteus, and the Avro Ashton test bed for the Olympus. (RRHT)

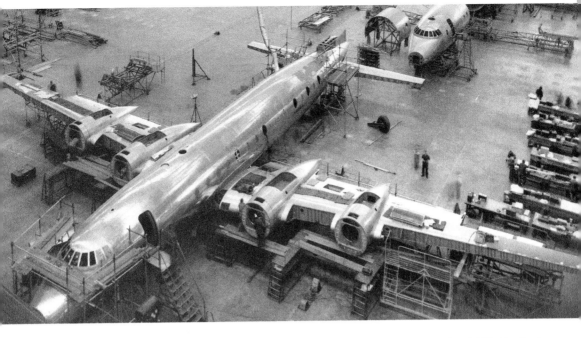

The first and second prototype Bristol Britannias under construction in the AAH. (Author's Collection)

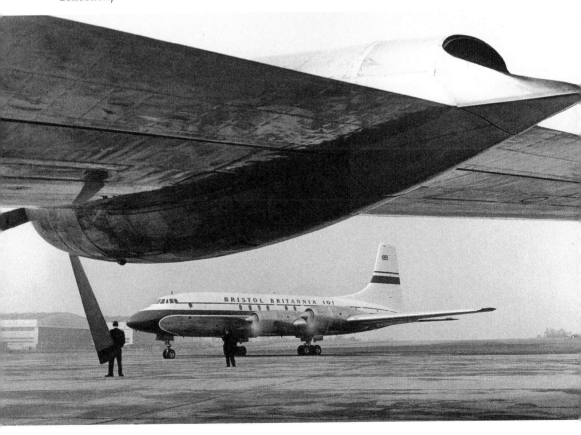

The first prototype Britannia, G-ALBO, at the end of the runway. (Bristol Aero Collection)

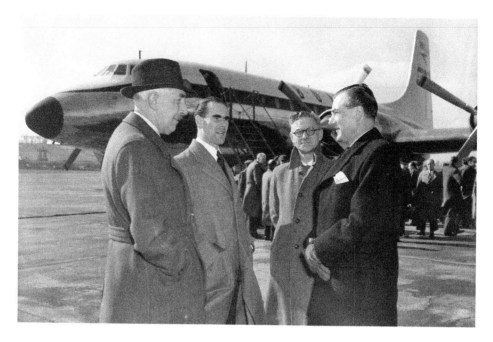

Britannia G-ANBA prepares for a flight from Filton to Khartoum and Johannesburg for tropical trials on 12 March 1955. From left to right: Cyril Uwins (Managing Director, Aircraft Division), Sir Reginald Verdon Smith (Bristol Joint Managing Director), Dr Archibald Russell (Chief Designer) and Sir David Eccles (Minister of Education). Just visible under the nose cone is the Rotor Spinning Tower. (Author's Collection)

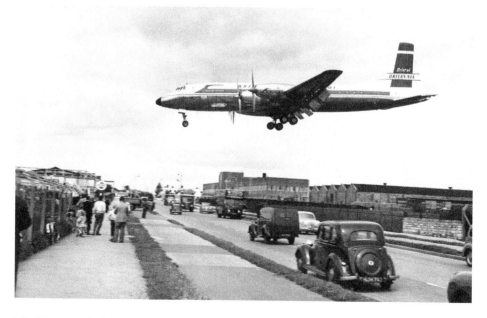

The first stretched Britannia, G-ANCA, on short finals over the Gloucester Road. First flown in July 1956, it had been painted in partial Capitol Airlines colours for a US sales tour later that year. Tragedy struck on 6 November 1957 when 'CA crashed at Downend while returning to Filton after a test flight. All fifteen souls on board were killed. (Geoff Church Collection)

501 Squadron re-formed at Filton in 1946, again as a reserve squadron, equipped with the Spitfire LF.XVIe. The squadron also used a Harvard for training. (501 Squadron Association)

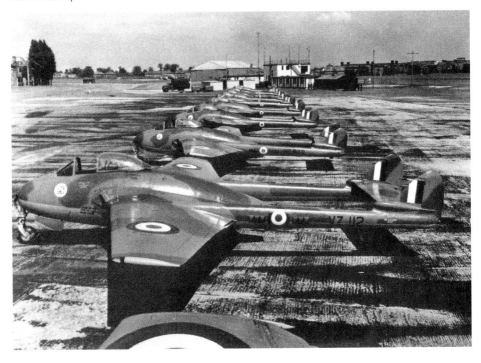

501 Squadron entered the jet age in 1948 with the arrival of the de Havilland Vampire. These Vampire FB.5s were lined up at Filton for an AOC inspection in 1955. (501 Squadron Association)

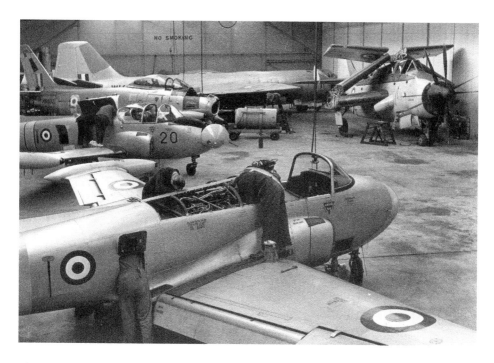

The Bristol Siddeley hangar around 1961. Visible are two Jet Provosts, a Sabre, a Canberra and a Gannet. All were used for engine development. (RRHT)

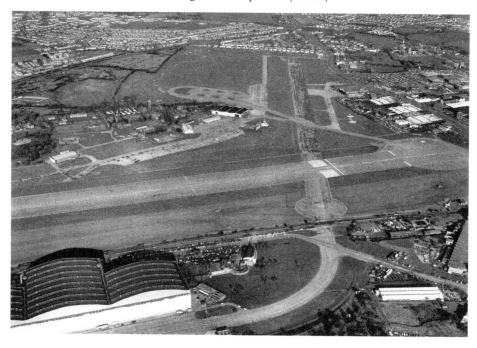

An aerial view of the airfield looking north-east. The Aircraft Assembly Hall is bottom left, West Works middle right, and the RAF base left of centre. Just above centre is the Vulcan dispersal site, which consisted of four parallel parking bays and a direct taxiway to the runway. (RRHT)

CHAPTER 5

Supersonic Travel

In the 1960s, the focus was on speed. The first aircraft to fly after the formation of the British Aircraft Corporation was the Type 188, which retained the 'Bristol' name. Two prototypes were built from stainless steel to test the effect of kinetic heating on an aircraft flying for long periods at Mach 2, twice the speed of sound. The first flight was on 14 April 1962, but the research project was abandoned in 1964. The thirsty engines only allowed for around twenty-five minutes of flight, which was not enough time to reach Mach 2, let alone achieve sustained flight at this speed.

The government formed the Supersonic Transport Aircraft Committee (STAC) in 1956 to promote the development of a British-engineered supersonic airliner. Several UK manufacturers worked on their own designs, and Bristol used the Type number 198 to cover a series of remarkable designs, eventually settling on a 136-passenger, six-engined delta winged aircraft, capable of Mach 1.8. In 1959, STAC decided that the Bristol 198 was superior to those from other companies, and Filton was given the go-ahead to develop their proposal. This evolved into the Type 223, which was a four-engined, delta winged transatlantic 110-seater. At the same time, Sud Aviation of France unveiled their supersonic proposition, the Super Caravelle, which was smaller than the 223 and was intended for short to medium range routes. As each project was facing huge development costs, it was announced in November 1962 that both countries would collaborate, producing both the long and the short/medium range aircraft. The latter was eventually dropped, due to a lack of interest from airlines, and the Type 223 developed into the Concorde project.

The chosen engine for the supersonic airliner also had a Bristol pedigree. The Bristol-Siddeley Olympus was the world's first twin-spool turbojet, and was test flown at Filton in a modified Canberra, which broke the world altitude record in 1953 and again in 1955 – both times flown from Filton by Walter Gibb. An afterburning version of the Olympus was tested at Filton, underslung on an Avro Vulcan. Development of the Olympus 593, used on Concorde, was started in 1964 as a collaboration between SNECMA of France and Bristol-Siddeley. An Avro Vulcan at Filton was again used to test this engine.

The manufacture of sub-assemblies for Concorde was proportionally distributed around aircraft factories in the UK and France with the only duplication being the assembly lines: one in the Aircraft Assembly Hall at Filton and one at Toulouse. Components were transported by road, sea and occasionally by air in a heavily modified Boeing Stratocruiser, called the Super Guppy. The first Concorde was rolled out in September 1968, and flew eight months later. Although Filton's runway was extended again in the mid-1960s, it was still not suitable to handle the Concorde development work that would be required in the coming years. RAF Fairford in Gloucestershire was chosen as the home for the Concorde development team, and when the first British Concorde took off from Filton in 1969, it flew straight to Fairford.

Six development Concordes were built before the production aircraft flew, three at Filton and three in France. At Filton, these were the British prototype, 002, a pre-production model, 101, and an intermediate model, 202, known as 'production test'. The latter aircraft, first flown on 13 February 1974, did much of the certification work for Concorde, and carried on as a development aircraft even after production finished. Environmental and noise issues, along with high oil prices, meant the order book dropped from over 100 to just five for British Airways and five for Air France. An additional two 'white-tail' Concordes were built at Filton without a prospective customer, and were eventually acquired by BA for a token amount in 1979. In all, ten Concordes were built at Filton, half of the overall production tally.

Concorde 202 returned to Filton after the closure of the flight test centre at Fairford in November 1976, and continued in the role of developing modifications to the production fleet. Its last flight was on 24 December 1981, and in 1984 British Airways acquired it as a source of spares for the main fleet. After seven years parked in the open, a hangar was built near the 501 hangar to house it, but the tail and nose cone were removed to fit it in. Over the next sixteen years it continued to be used as a development airframe; underwing panels were used in the investigation and reconstruction of the Paris Concorde crash in 2000, and bullet-proof doors were developed to comply with new regulations after the attacks in the USA in September 2001.

Following the sharp downturn in the airline industry after 2001, BA and Air France jointly announced the grounding of Concorde in early 2003. All refurbished aircraft were distributed for preservation, and the last ever flight by a Concorde was made on 26 November 2003 when the last Concorde built, 216, landed at Filton. The following year a visitor centre opened on the airfield, staffed by volunteers, close to the AAH where the Concordes were built. Over the next six years, organised tours and corporate events raised over £300,000 towards a fully fledged museum at Filton. Filton's other Concorde, 202, was offered to the Brooklands Museum in Surrey, and in early 2004 it was carefully cut up and transported to Brooklands in sections, where it has now been refurbished for display.

The Concorde flight simulator, used to train British Airways pilots, was also acquired by the Brooklands Museum in 2004. Installed in a building within the BAC factory, it stood fifteen feet off the ground on its hydraulic rams, which gave the pilots the sensation of being in flight. The original set-up consisted of a camera and a vertically-mounted model landscape, but this was replaced by a computerised system in 1987. The new system included many airports around the world, and for a more unusual destination, it had an aircraft carrier in the middle of the Pacific Ocean. It has been reactivated at Brooklands using standard flight simulation software, but without the hydraulic rams.

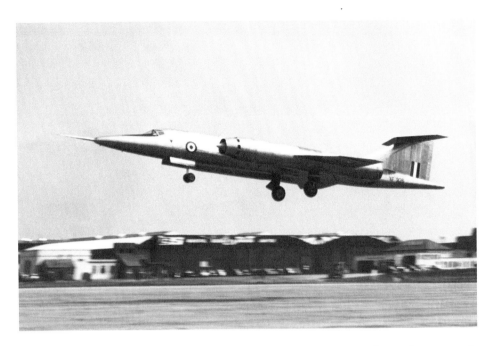

The stainless steel Type 188 was built to investigate the effects of high speeds on aircraft. Powered by de Havilland Gyron Junior turbojets, it proved to be unable to reach its target speed of Mach 2. This was partly due to excessive fuel consumption, which reduced its planned flight time considerably. (Duncan Greenman via RRHT)

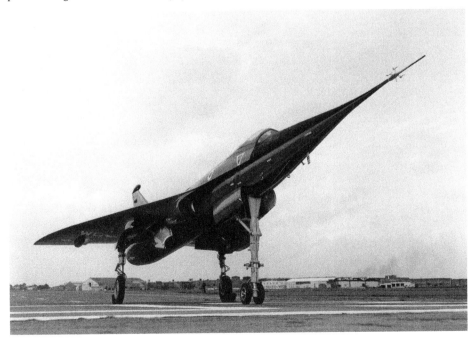

The Type 221 was a modified Fairey Delta FD.2 with an ogee-shaped wing, lengthened undercarriage, and up-rated Rolls-Royce Avon engine. It arrived at Filton in 1960, and made its first flight in modified form in April 1964. (Duncan Greenman via RRHT)

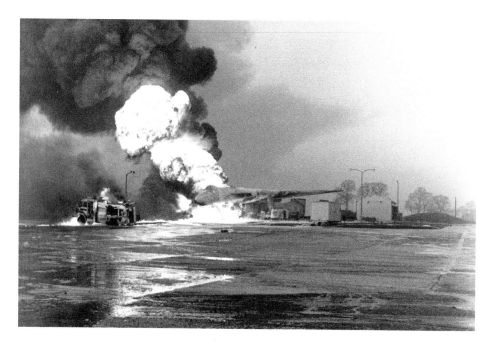

When it came to testing the Olympus 22R turbojet engine planned for the TSR-2, Bristol-Siddeley used a Vulcan, XA894, as the test aircraft. On 3 December 1962, the engine was being run on maximum reheat on the ground when a disc exploded, shooting debris into the fuel tanks. The crew escaped quickly, but the intense fire could not be put out, and was left to burn. A brand new fire tender was consumed in the flames. (RRHT)

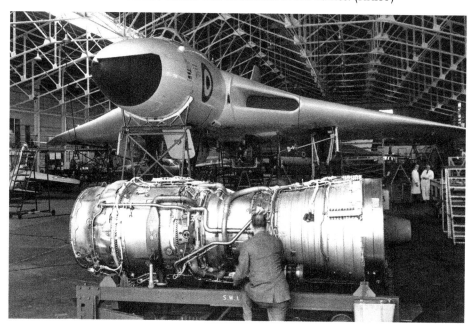

Avro Vulcan XA903 was the flying test bed for the Olympus 593 turbojet, destined for Concorde. It first flew with the 593 in September 1966. In the background are a variety of engine test aircraft, including two Gnats and a Buccaneer. (RRHT)

This was called the Runway Garage for obvious reasons. In 1960, a Vulcan aborted its landing in bad weather, applied full power to overshoot, and was so low as it came over the A38 that its jet blast ripped up the pumps and spun cars around. The garage was relocated soon after. (RRHT)

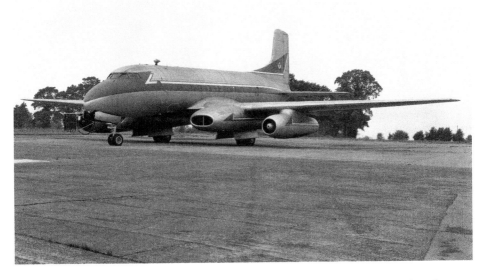

Avro Ashton WB493 was used as a test bed for an experimental version of the Olympus turbojet engine from 1955. The aircraft appeared as the fictional 'Atlas Phoenix' in the 1960 film *Cone of Silence*, which includes many scenes shot at Filton. For authenticity, the engine test site was covered in sand and potted palm trees, and has been known as 'Palm Beach' ever since. (Geoff Church Collection)

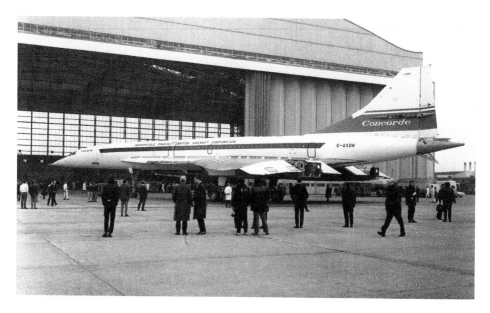

The second Concorde to be assembled at Filton was the pre-production model, 101, registered G-AXDN. It was rolled out on 20 September 1971. (Duncan Greenman)

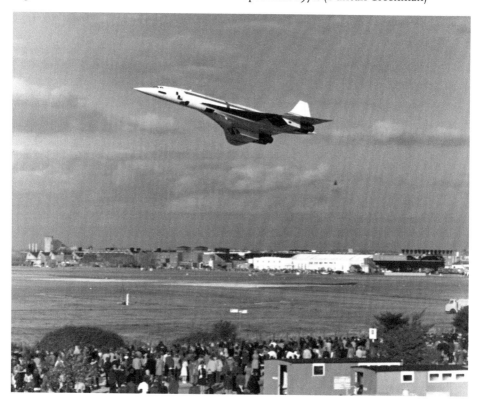

Concorde 101 performs a low flypast at Filton during the 1974 Rolls-Royce Air Day. A few months later, this aircraft was to make the fastest ever east-to-west Atlantic crossing by a commercial airliner – 2 hours 56 minutes from Fairford to Bangor, Maine. (RRHT)

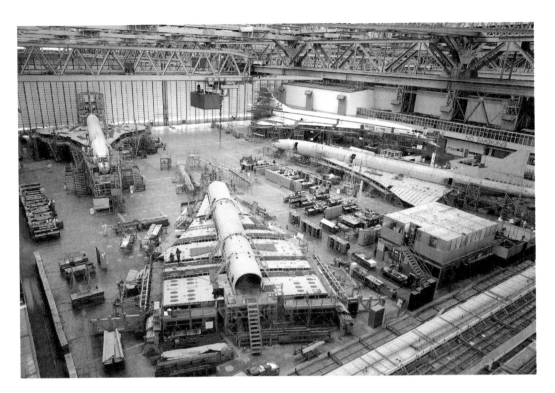

Concordes under assembly at Filton. The painted example is G-BOAC, the first to be delivered to British Airways, which made its first flight at Filton on 27 February 1975. (Duncan Greenman)

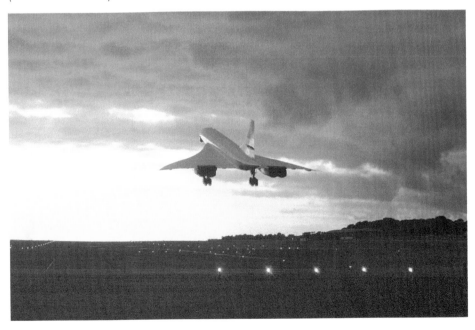

A British Airways Concorde landing at Filton, returning from a charter flight around the Bay of Biscay in the mid-1990s. (Bob Holder)

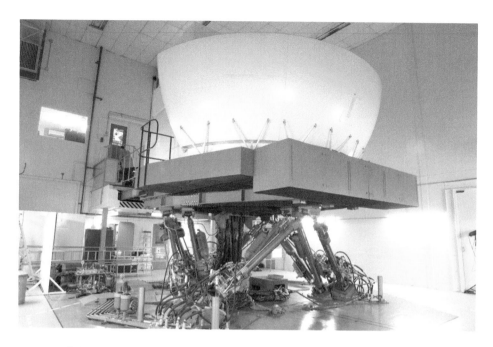

In 1975, a fully mobile simulator was commissioned at Filton to train British Airways pilots on Concorde, at a cost of £3 million. It stood 15 feet off the ground on its hydraulic rams, which gave the pilots the effect of being in flight. The original setup consisted of a camera and a vertically-mounted landscape, but this was replaced with a computerized system in 1987. (Bob Holder)

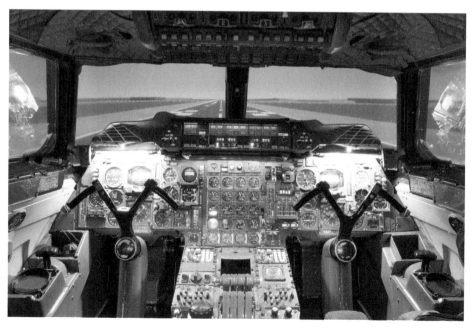

The simulator was decommissioned in 2004 and dismantled. It was acquired by the Brooklands Museum, without the computers and hydraulic rams, but has since been reactivated using standard flight sim software. (Bob Holder)

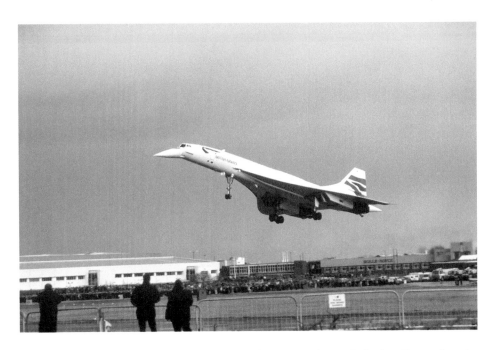

The last flight of a Concorde was on 26 November 2003, when 216, the last Concorde to be built, landed at Filton for preservation. (Author)

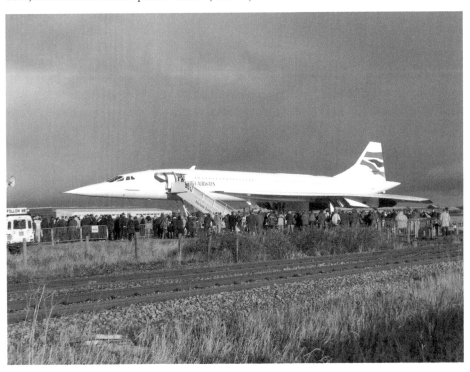

The passengers alighting from the aircraft had the honour of being the last to fly in a supersonic airliner for the foreseeable future. Prince Andrew later accepted the log book on behalf of the people of Bristol. (Author)

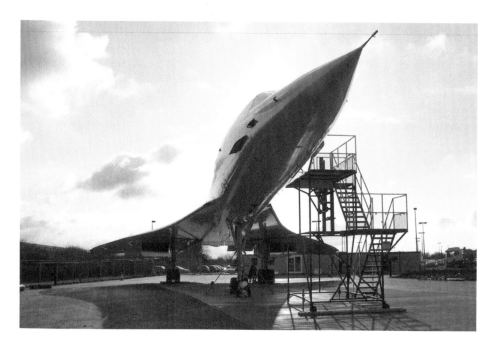

Concorde 216 in March 2004, on the site of the visitor centre, which opened in the following August. It closed in 2010 to allow for some major maintenance work, but did not re-open. It will be the centrepiece of the proposed heritage centre on the airfield. (Author)

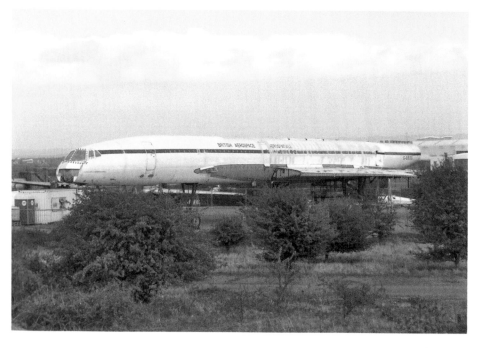

Concorde 202 on Palm Beach in April 2004. It served as a development aircraft until 1981, then spent the next twenty-three years in storage at Filton as a source of spares. It was dismantled in 2004 and transported by road to the Brooklands Museum, where it has now been restored as a museum exhibit. (Author)

CHAPTER 6

Re-Use and Decline

As the last Concorde flew out on delivery to British Airways in June 1980, so ended seven decades of aircraft production and assembly at Filton. Almost 16,000 aircraft had been built since 1910, at Filton and at shadow factories elsewhere. When the British Aircraft Corporation merged with Hawker Siddeley (HS) in 1977 to form British Aerospace (BAe), the HS Works at Hatfield closed soon after, and the Airbus wing work transferred to Filton. Airbus A320 wings were built here and flown to Toulouse in the Super Guppy. This work was transferred to Broughton near Chester after 450 wing sets had been delivered. Airbus at Filton became the centre for the design of Airbus wings in 1990, and continues to build components such as wing boxes and carbon fibre wings for the A400M. The site has also been responsible for the design of landing gear and fuel systems for Airbus aircraft.

The immense size of the AAH made it ideal for other contracts, especially for large aircraft. Canberra and Valiant bombers were upgraded at Filton in the early 1960s, and nine ex-airline VC-10s were converted to tankers for the RAF in the period 1977 to 1984. Another five VC-10s were converted to tankers in the early 1990s. Continuing the military theme, several hundred UK-based USAF F-111 fighters were worked on at Filton between 1978 and 1992.

A division of BAe called Aviation Services was set up in 1992, based in the AAH. This unit performed maintenance and servicing initially on the Airbus A300, but later expanded to include the Airbus A320 family and the BAe 146. In 1997 the conversion of A300s from passenger to cargo configuration was added. At times, as many as thirty Airbus A300s would be either parked up on the airfield or being worked on in the AAH. Market conditions forced the closure of Aviation Services in 2002, but BAe 146 work continued in the West Bay until late 2004, when it moved to Kemble.

After the demise of Aviation Services, the AAH was made commercially available for rent. Two companies arrived in 2003; Air Livery set up an aircraft paint shop in the East Bay, and MK Airlines moved into the Centre and West Bays with a maintenance base for their fleet of freighters. Air Livery already had a facility at Southend, but this could not handle large airliners, which the West Bay was ideally suited for. Most of the aircraft repainted here were owned by leasing companies, coming off lease from one airline and requiring a repaint in to the colours of its next operator. Around 260 aircraft were painted at Filton up to June 2009, when the operation re-located to Manchester Airport.

MK Airlines was originally an African cargo airline, but became a UK registered company in 2006. Its fleet of elderly Douglas DC-8s and Boeing 747s operated on every continent, but it still kept a significant presence in Southern Africa. Boeing 747s of Russian airline Transaero were also serviced by MK. The airline was renamed British Global in 2007, although the aircraft still carried MK titles. A number of executive aircraft were acquired in 2008 and 2009, namely a

Gulfstream I and two Boeing 727s. The company's expansion plans led to the airline going into administration twice, once in June 2008 and again in April 2010, the second time leading to a permanent suspension of operations.

The Avon & Somerset and Gloucestershire constabularies combined forces in 1995 to operate a Police helicopter to cover the area. An Aerospatiale Squirrel was acquired by the Western Counties Air Operation Unit, and in July 2002 this was replaced by a Eurocopter EC135. Filton received its second emergency helicopter service in 2008, in the form of the Great Western Air Ambulance. The helicopter, a Bolkow 105, is crewed by a pilot and two paramedics, and operates seven days a week during daylight hours. The paramedics are employed by the NHS, and almost half of the incidents they attend are by road rather than by air. The small helicopter can carry one stretcher, but its real advantage is with the life-saving equipment it carries, including some kit not normally carried in regular ambulances. This means that the paramedics are able to treat any injuries on the scene, bringing the hospital to the patient. GWAA started an appeal to acquire a larger helicopter, a Eurocopter EC135, in July 2012.

Plans for a museum at Filton started in the late 1980s when several interested individuals got together and formed the Bristol Aero Collection. Initially, premises were found at Banwell in Somerset in a former BAC shadow factory. For the first time, artefacts could be gathered together in one place, including a Sycamore helicopter, Bloodhound missile, and the nose of the prototype Britannia that force-landed on the Severn in 1954. The Collection moved to Kemble in 1995 when the Banwell site was cleared for redevelopment. Kemble gave the Collection the opportunity to expand and open to the public on a regular basis. A committee was formed in 2000 to plan a heritage centre at Filton and the arrival of Concorde in 2003 increased public awareness of the scheme. A proposal to build a museum near the Mall shopping centre at Cribbs Causeway had reached the funding stage, but with news of the closure of the airfield it was abandoned in favour of re-using the surviving RAF hangars, as their Grade II listed status meant they were ideal for this use.

The decline in use of Filton Airfield started in the 1990s. Bristol University Air Squadron moved out to Hullavington in March 1992, ending nearly eight decades of RFC and RAF involvement at Filton. The Rolls-Royce flight test centre closed around 1995, and the West Works were demolished to make way for the Royal Mail West of England sorting office. In 1993, BAe attempted to turn Filton into a commercial airport, restricted to smaller commuter aircraft, but the plans were dropped in the face of stiff opposition from local residents.

The closure of Filton airfield was announced in April 2011, giving over 18 months notice. By this time, the only major user of the airfield was Airbus, who used it for daily staff shuttle flights between Filton, Broughton, and Toulouse, and for the export of A400M wings to Seville by Beluga, the successor to the Guppy. Almost immediately, a local organisation was formed called Save Filton Airfield, who proposed that the permanent loss of such an important West Country asset would have a devastating effect on the local economy and Britain's aviation industry. The airfield owners, BAE Systems, cited reduced traffic figures and stated that all alternative uses had been investigated and ruled out. The sale of land to the north of the runway for redevelopment in 2002 had left Filton Airfield as a narrow strip with no land to build any facilities that a based operator would need.

Airbus has started work on a new Aerospace Park on the eastern side of the factory which will include the much-needed restoration of the grade II listed Art Deco Filton House. The Police and Air Ambulance helicopters are to stay at Filton for the foreseeable future. In 2012, the Bristol Aero Collection at Kemble closed its doors in preparation for the new heritage centre at Filton. This centre will have Concorde 216 as the centrepiece of a museum worthy of the history of aviation at Filton. So, as one chapter ends, another one begins.

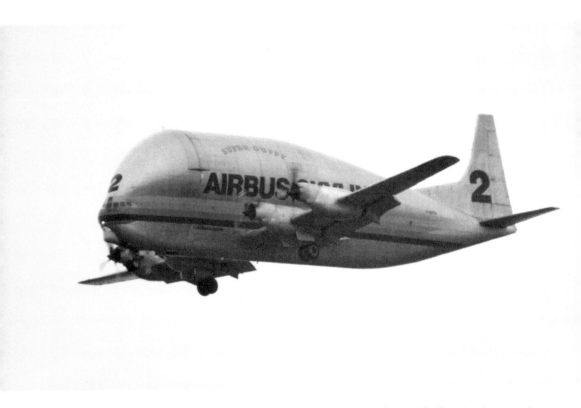

A Super Guppy on approach to Filton. The Super Guppy was a heavily modified Boeing Stratocruiser, and was initially used to transport Concorde fuselage sections between the assembly lines at Toulouse and Filton. It was later used to carry Airbus A320 wings from Filton to Toulouse. (Geoff Church)

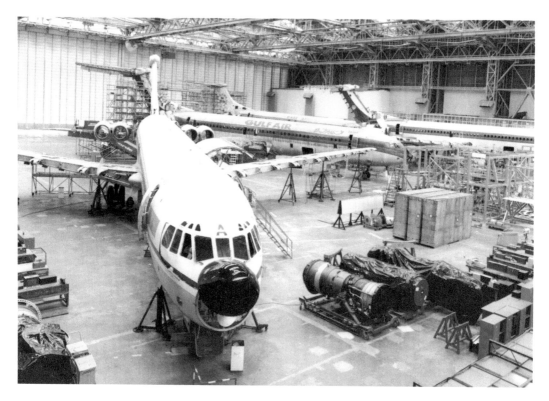

Nine former Gulf Air and East African VC-10s were converted to tankers for the RAF in the early 1980s. In the foreground is 5Y-ADA, which became ZA148, the first K3 variant to fly, on 4 July 1984. (Duncan Greenman via RRHT)

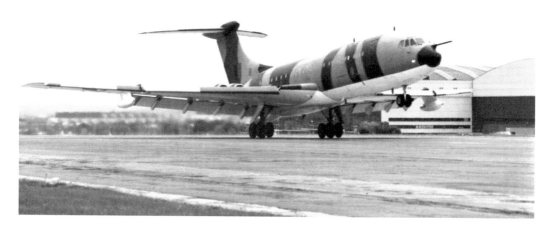

The first VC-10 conversion at Filton, ZA141, a K2 variant, made its first post-conversion flight on 22 June 1982. It was unique in that it was the only RAF VC-10 in camouflage. The other Filton conversions were delivered in hemp or grey. (RRHT)

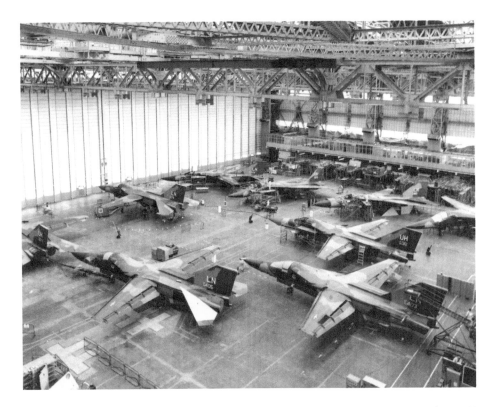

A batch of USAF F-111F fighters from Lakenheath undergoing maintenance in the AAH West Bay. The contract started in 1978 and finished in 1992 when the F-111 fleet left Europe. (Duncan Greenman via RRHT)

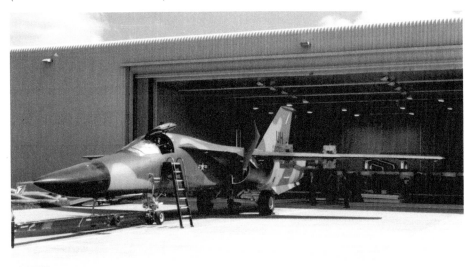

A USAF F-111E from Upper Heyford outside the cold soak facility in September 1986. This building could test the steel wing structure at -40° C. (George Rollo)

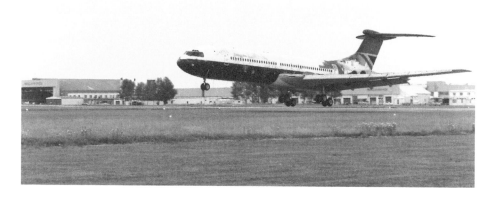

A second batch of VC-10s were converted to tankers in the early 1990s. These former British Airways aircraft had been parked at RAF Abingdon in Oxfordshire for almost a decade before being made airworthy and flown to Filton with the undercarriage down and chase plane escort. They had been wrapped in Driclad bags, but where these had disintegrated, a greasy protective coating was added, giving a patchy appearance as seen on ZD242 in July 1990. (Duncan Greenman)

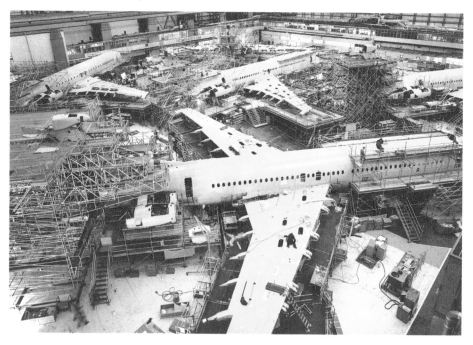

VC-10s under conversion to tankers in the AAH. The second batch comprised five ex-British Airways Super VC-10s, which became the VC-10 K4 in RAF service. (Duncan Greenman)

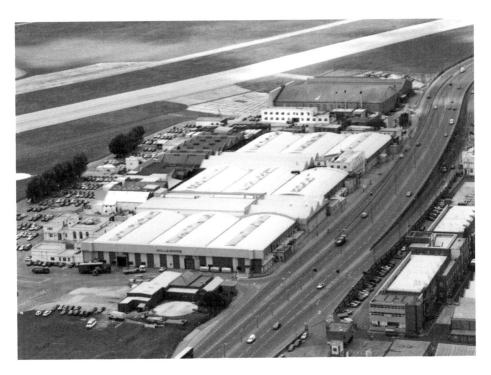

West Works in 1991. The entire site was demolished in about 1995 and redeveloped as the Royal Mail West of England Sorting Office. (RRHT)

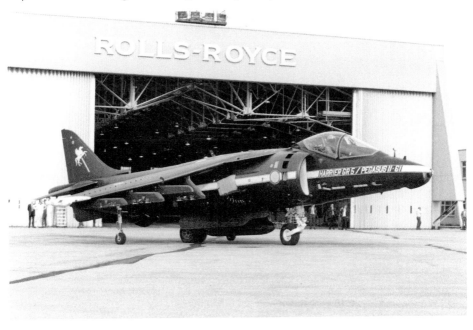

This Harrier GR5 was converted into the Rolls-Royce Pegasus 11-61 test bed. Following 36 hours of flight testing, four time-to-height world records were set on 14 August 1989. BAe test pilot Heinz Frick set the records for 6,000m and 12,000m, and Rolls-Royce Chief Test Pilot Andy Sephton set the 3,000m and 9,000m records. (RRHT)

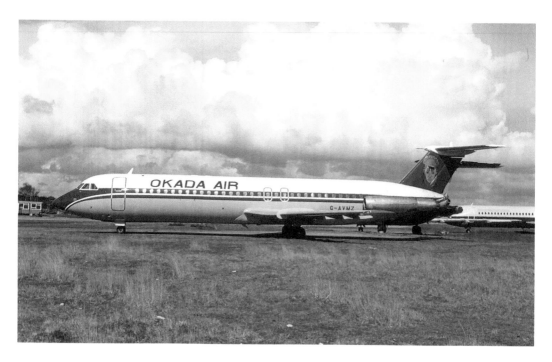

G-AVMZ was one of a number of ex-British Airways One-Elevens due to go to Okada Air of Nigeria but never delivered. European Aviation acquired these with the rest of the BA One-Eleven fleet in 1993 and set up a maintenance base at Filton. (Bob Holder)

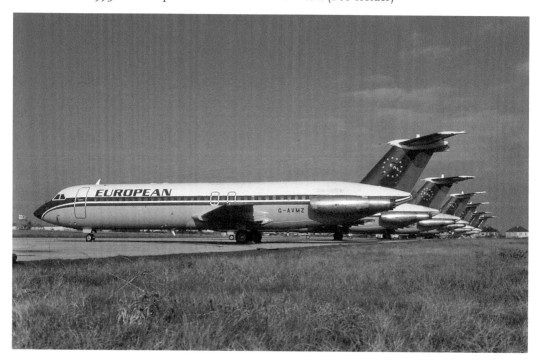

This line-up of One-Elevens at Filton shows G-AVMZ again, this time with European titles. (Bob Holder)

Air Bristol was formed in 1993 using One-Elevens leased from European. The intention was to operate charters from Filton, but when plans to turn Filton into a commercial airport fell through, the operation moved to Stansted, and became AB Airlines in 1997. The airline operated the Airbus factory air bridge between Filton and Toulouse from October 1993 to May 1998. (Geoff Church)

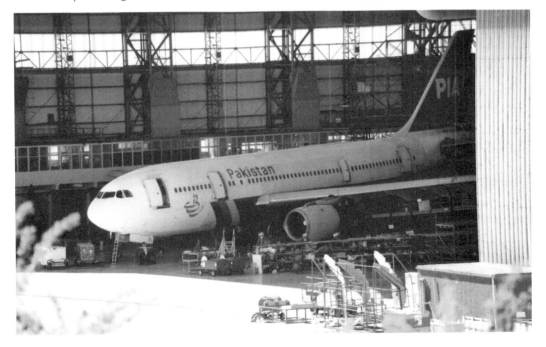

Airbus A300 AP-BFL, formerly of Pakistan Airlines, undergoing overhaul in the AAH in June 2000. It was delivered to Mahan Air of Iran the following month. (Author)

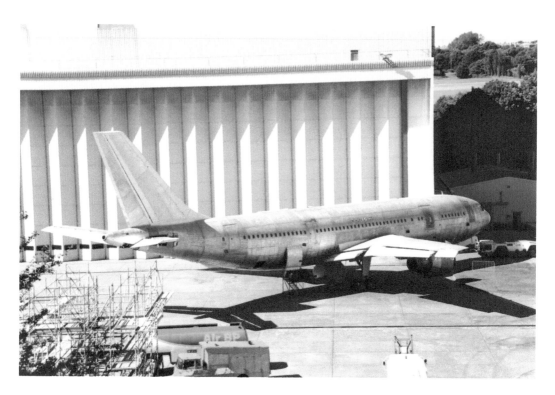

An Airbus A300 stripped to bare metal, during a hangar re-shuffle in June 2000. Halfway along the fuselage is its identity, 'MSN084 S/S035', indicating it is the eighty-fourth Airbus A300 built, and the thirty-fifth A300 cargo conversion at Filton. It was delivered to DHL as N362DH in November 2000. (Author)

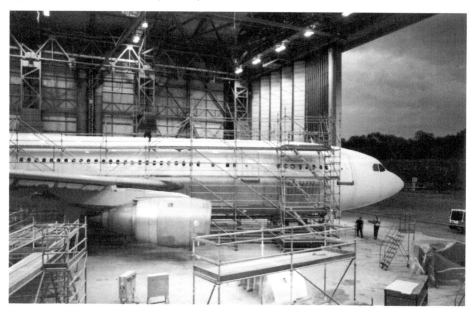

Airbus A300 F-WIHY undergoing conversion to freighter in West Bay in May 1999. (Author)

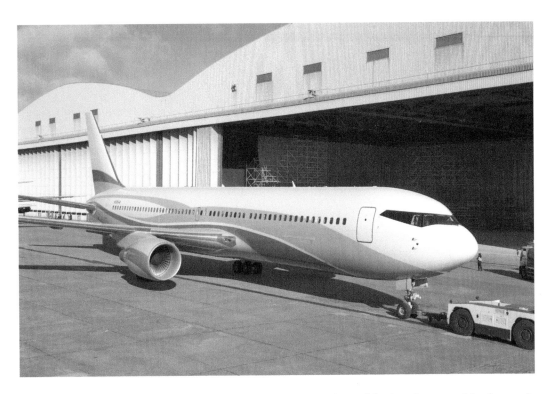

This Boeing 767 for Roman Abramovich is being reversed out of the East Bay on 22 March 2004. It had arrived the previous month from Basel, where a VIP interior had been fitted. (Bob Holder)

This Boeing 747 of Virgin Atlantic was one of the last aircraft to be painted by Air Livery at Filton, in June 2009. (Bob Holder)

This Airbus A330 arrived in Swiss International colours, and was repainted in Vietnam Airlines livery in April 2009. (Bob Holder)

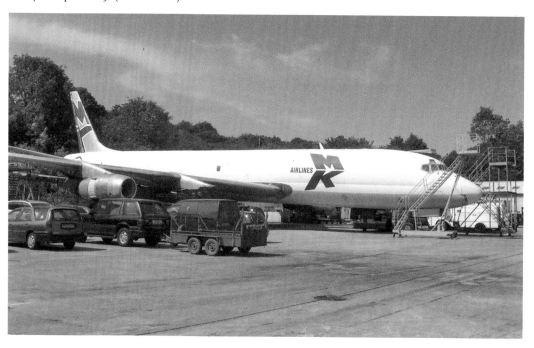

MK Airlines established a maintenance base at Filton in 2003, in the Centre and West bays. This DC-8F 55, 9G-MKC, was broken up in 2008 after three years as a source of spares for other aircraft in the fleet. (Author)

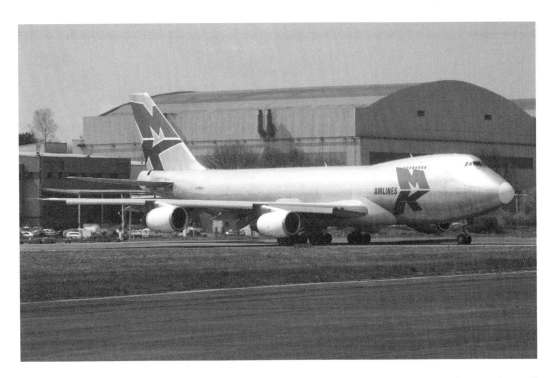

MK Airlines Boeing 747 G-MKGA prior to departure after a two-day stopover in the AAH in April 2008. (Shaun Connor)

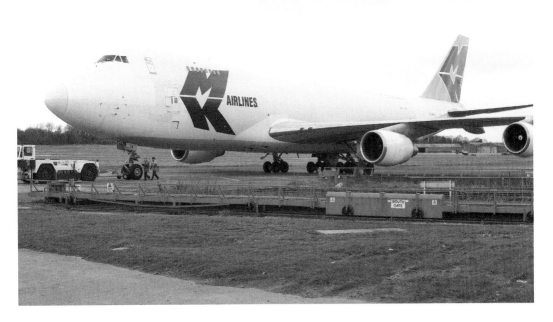

MK Airlines Boeing 747 G-MKFA being towed over the level crossing to the AAH in March 2008. (Shaun Connor)

With offices in different locations, 'air bridges' were regularly used to ferry staff from one site to another. BAE Systems operated their own fleet of Jetstream 31s around the UK, but this was outsourced in 2003 to Eastern Airlines, who maintained the fleet in BAE house colours. (Author)

Privatair were contracted to operate the Broughton–Filton–Toulouse air bridge from June 2003. Two Airbus A319s in corporate configuration were acquired for the route. The contract was replaced by WDL in March 2008. (Adrian Falconer)

In May 2006, this Airbus A380 made a very low pass at Filton en route to Heathrow, on the first visit of the type to the UK. Filton is responsible for the design of A380 wings, as well as the integration of the landing gear and fuel systems. It also manufactures wing components. (Bob Holder)

On 1 February 2008 an Airbus A380 made the first flight of a commercial aircraft using a synthetic fuel, flying from Filton to Toulouse. (Shaun Connor)

The centenary of aircraft production at Filton was celebrated on 19 February 2010 with the launch of BAC100, a year of exhibitions, talks and other events. The launch took place in East Bay, and the RAF Museum loaned their preserved Bristol Bulldog for the day. (Author)

Highlight of the BAC100 launch was the naming of an Easyjet Airbus A320 after Sir George White, the founder of the British & Colonial Aeroplane Company in 1910. The naming was performed by Sir George White (4th baronet) and Lady White. (Author)

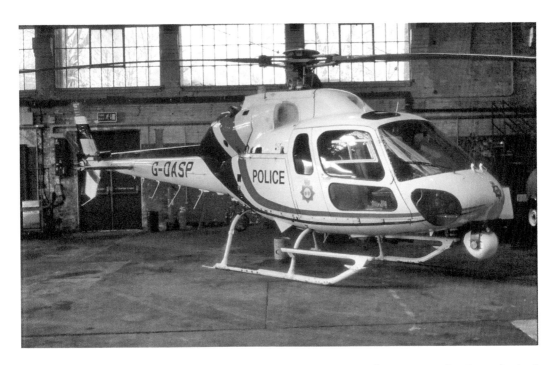

The first Filton-based police helicopter was acquired in 1995. The Aerospatiale AS 355 Squirrel was appropriately registered G-OASP for Avon & Somerset Police. (Author)

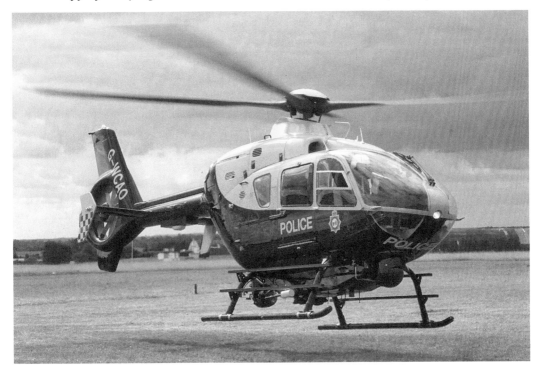

The police Squirrel was replaced by a Eurocopter EC135, registered G-WCAO for Western Counties Air Operations, seen here at Kemble in 2003. (Author)

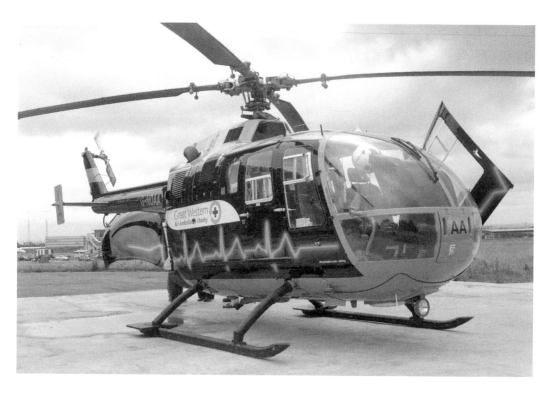

Filton is home to the Great Western Air Ambulance, a charity-run emergency helicopter service that is called out around 600 times a year. (Author)

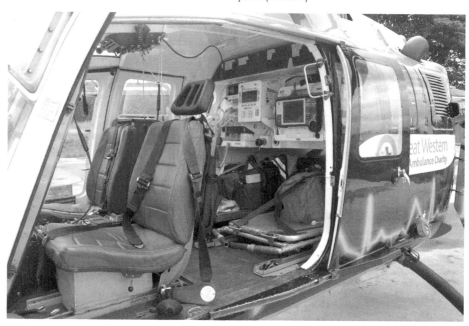

The cramped cabin of the Air Ambulance Bolkow 105 holds a pilot (who sits on the right) and two paramedics. When carrying a patient, the stretcher is loaded through clam-shell doors at the rear. (Author)